IMAGES
of America

NORTHERN ARIZONA
SPACE TRAINING

IMAGES
of America

NORTHERN ARIZONA
SPACE TRAINING

Kevin Schindler and William Sheehan
Foreword by Carolyn Shoemaker

ARCADIA
PUBLISHING

Published by Arcadia Publishing
Charleston, South Carolina

Printed in the United States of America

Library of Congress Control Number: 2016959111

For all general information, please contact Arcadia Publishing:
Telephone 843-853-2070
Fax 843-853-0044
E-mail sales@arcadiapublishing.com
For customer service and orders:
Toll-Free 1-888-313-2665

Visit us on the Internet at www.arcadiapublishing.com

*To the memory of Gene Shoemaker, who
pioneered the field of astrogeology*

CONTENTS

FOREWORD

In 1948, Gene Shoemaker was becoming aware at the age of 20 that man would go to the moon during his lifetime. He realized that this was where his ambitions lay and was determined that he would do everything possible to take part in a mission. Ultimately, he was unable to become an astronaut himself, but he worked hard to ensure that there were scientist astronauts selected and that there was a science program within NASA and in the US Geological Survey (USGS), set up in Flagstaff, Arizona, as the Branch of Astrogeology in 1963.

Flagstaff and the area around it offered a wealth of opportunities to study the kind of geology that astronauts might encounter on the moon and to observe and photograph its surface with the aid of astronomers and telescopes at Lowell Observatory and the US Naval Observatory. The need for lunar geological maps of scientifically productive areas and safe exploration sites brought much of the staff from Menlo Park. Ultimately, the staff in Flagstaff grew to 200 scientists, engineers, and technicians as the various space missions took shape.

In 1963, nine newly selected astronauts began their training in geology with a two-day field trip to Meteor Crater and the nearby volcanic features. There were classroom lectures and telescope observing. Over the course of time, different groups of astronauts did fieldwork at the Grand Canyon, in Hawaii, in Iceland, and in various places around the country that offered experiences the USGS geologists deemed worthwhile. Mission support studies blossomed in 1964. Finally, all their intense planning came to fruition in 1969 as astrogeologists watched Apollo 11 make the first manned lunar landing, with two astronauts stepping onto the moon's surface.

The Branch of Astrogeology, now known as the Astrogeology Science Center, continued to work with the astronauts during the time of Apollo, and someone from this group has taken a hand in every space mission since. It remains a hub for those interested in learning about our universe and the worlds around us.

—Carolyn Shoemaker

ACKNOWLEDGMENTS

We thank Carolyn Shoemaker for writing the foreword and sharing vignettes about her late—and legendary—husband, Gene. We also express our deep appreciation to the many astronomers and geologists whose writings, correspondence, friendship, advice, and images made this book possible, including Ewen Whitaker, David "Dai" Arthur, William Hartmann, Dale Cruikshank, Alan Binder, Charles Wood, Don Wilhelms, James Head III, Peter Schultz, Gerald Schaber, Richard Eggleton, Patricia Bridges, Terry McCann, and Robert Maulfair. We also appreciate the kindness of Alan Bean—the only artist to walk on the moon—for allowing us to use a picture of one of his spectacular moon paintings. We add expressions of gratitude to Don Lago, Drew Barringer, and Andy Chaikin for filling in important details of the stories briefly touched on here.

Our greatest debt may be to Flagstaff newspaperman and Lowell Observatory scholar William Graves Hoyt, whose articles, books, and mentoring helped launch at least one career in the history of astronomy. Leo Aerts, Klaus Brasch, and Bill Leatherbarrow inspired us with their unfettered zeal for the moon and were generous with images, while Walt Cunningham, Bill Ferris, and Dennis Foster helped identify people and locations in many of the images.

Thanks go to Lanah Butterfield, Mary DeMuth, Larry Wasserman, and Jeff Hall for editorial suggestions, and Caroline Anderson, title manager at Arcadia Publishing, for her hard work and patience in seeing this project through. For years, Adrienne Wasserman helped preserve the vast historical record of the USGS's contribution to the manned space program and helped spur interest in preserving this record, while David Portree of the USGS, whose knowledge of the lunar mapping program and USGS is encyclopedic in scope and always leavened with high good humor and interesting asides, was always generous with his time and knowledge.

Last but not least, we thank our families for ongoing support, patience, and good humor: Debb, Ryan, Brendan, Gretchen, Alicia, Addie, Brandon, Sommer, Senna, and Lauren.

INTRODUCTION

On May 25, 1961, just a month after the Bay of Pigs fiasco in Cuba, Pres. John F. Kennedy boldly announced to a joint session of Congress: "I believe that this nation should commit itself to achieving the goal, before this decade is out, of landing a man on the moon and returning him safely to Earth."

In his classic book on the geology carried out on the Apollo missions, *To a Rocky Moon*, Don E. Wilhelms writes, "Kennedy gave us a goal and purpose such as a nation rarely offers its citizens in peacetime." Of course, it was not quite peacetime. Though there was not a "hot war" with the Soviet Union, the Cold War was in full swing, and America's rival superpower clearly understood that the long-term commitment to the space program had military objectives. The half billion dollars Kennedy asked of Congress for the space race in 1962, generous as it was, was greatly exceeded by his call for large increases in other military spending in an across-the-board arms race with the Soviets. Moreover, Kennedy himself was only interested in the imposing goal of reaching the moon as part of what space historian John M. Logsdon has called "the battle along the fluid front of the Cold War." In a 1963 tape released by the Kennedy presidential library in 2001, Kennedy says, "I'm not that interested in space. I think it's good, I think we ought to know about it. But we're talking about fantastic expenditures. . . . The only justification for it, in my opinion, is to do it in the time element I'm asking, in other words to win the race to the moon."

As Kennedy saw it, the point was to beat the Russians to the moon, thereby demonstrating America's technological prowess and the superiority of the free world to the Communist system. At the time Kennedy gave his speech, the Russians, in fact, seemed well in the lead. (It must be remembered that the early rockets into space were essentially modified ballistic missiles; thus, superiority in booster delivery systems obviously had implications for the nuclear arms race.)

In setting the goal of reaching the moon, Kennedy and his successor, Lyndon Johnson, launched Project Apollo. It was underwritten during an era of "budgetless financing" for NASA (National Aeronautics and Space Administration), the likes of which would never be seen again. Indeed, NASA's budget grew from 0.1 percent of the total federal budget in 1958, the year of NASA's founding, to not quite 1 percent in 1961, then to a torrid 4.31 percent and 4.41 percent during the peak years of 1965–1966. (In 1965, an estimated 411,000 Americans worked for NASA as in-house employees or for its contractors, while in 1969, the year of the Apollo moon landing, the number was still over 200,000—a number that has not been approached since.) In the almost half-century since the Apollo program ended in 1972, the NASA budget has rarely passed 1 percent; since the financial crisis of 2008, it has settled around a rather anemic 0.5 percent.

Despite the commitment of "fantastic expenditures," it was at first far from certain that the scientific exploration of the moon would have any role in the upcoming moon missions. Kennedy's own view seems to have been largely shared by the American people—they, too, by and large, had little interest in the moon for its own sake, as an object of scientific investigation. It seemed

a grim, lifeless world, a scarred waste of burnt-out cinder cones. Even NASA headquarters needed convincing. Wilhelms writes: "It was not foreordained that Apollo would be influenced by geology or any other science." The person who deserves more credit than any other that Apollo would be so influenced was Eugene Merle "Gene" Shoemaker, the main character of this book. Shoemaker spent the year 1963 in Washington lobbying for an ambitious lunar science agenda. Supported by Homer Newell, NASA's director of space sciences at the time, and his deputy, Oran Nicks, Shoemaker was strongly opposed by Dyer Brainerd Holmes, an electrical engineer who was appointed head of the Office of Manned Space Flight. "Holmes's attitude to scientists," notes Wilhelms, "was, essentially, 'buzz off.' The president had directed us to get Americans to the Moon and return them safely to Earth in this decade, but nowhere did he mention picking up stones or taking pictures . . . If Shoemaker had not gone to NASA Headquarters to lobby for geology, and if Holmes had stayed there (he left in September 1963), it is entirely possible that we would have no samples or photographs from the lunar surface."

That same year—1963—Shoemaker was diagnosed with Addison's disease, thus ending his own long-cherished dream of reaching the moon himself. But he managed to persuade the NASA brass that science, especially geology, would be an inseparable part of the Apollo program. Landing men on the moon would not be a mere technological stunt, however impressive. Rather, it would enduringly contribute to one of the greatest scientific adventures ever attempted and lead, to an extent no one could have anticipated in 1963, to a completely fresh understanding of our own place in the universe.

Meanwhile, there was much to be done to get ready. The first imperative, the mapping of the moon, was already well under way. Efforts were also commencing on how lunar landing and surface navigation would be accomplished. These entailed organizing appropriate training for the astronauts charged with their implementation.

In July 1962, NASA had adopted a plan for complicated spacecraft rendezvous for lunar missions. This meant that the missions would not be piloted by geologists and other scientists who had become amateur flyers, as Gene Shoemaker had once hoped, but by highly experienced test pilots. That being the case, it was clear that the astronauts would have to be the geologists' eyes on the moon, and to do so successfully, they would have to bone up on enough geology for them to be able to make efficient use of the time they had during their brief stays on the lunar surface. Part of this would involve classroom instruction, but they also needed geological fieldwork, and for this purpose, the astronauts would be dispatched to various geologically rich locales, largely in the Southwest—of which, first and foremost, was the geological wonderland of northern Arizona.

Since the astronauts were busy men, they were not likely to be any more enthusiastic at first about all of this than some of the NASA brass had been. They would have to be wooed and won by geology. Eventually, most of them would be, and this is where the unique landscapes of northern Arizona played an indispensable role. The astronauts were first captured—and given a rudimentary lesson in stratigraphy—among the grandeurs of the Grand Canyon. They also gained invaluable experience by studying features similar to those they were expected to find on the lunar surface in the surroundings of Flagstaff. At the time, the century-long debate about the origins of the craters, the moon's most characteristic features, had not yet been resolved: Were the craters impact features, or volcanic? In northern Arizona, there were outstanding examples of each class: Meteor Crater, the best-preserved meteorite-impact crater on the entire Earth, and a host of volcanic features of every type and description, including craters, cones, flows, and lava tubes. Whatever secrets the moon held in store for the astronauts, they were likely to have already encountered something similar in the landscapes around Flagstaff.

Northern Arizona, then, was in some ways a mock-up for the Apollo missions, a staging ground for the geological prospecting that the astronauts carried out between the time Apollo 11 landed in the Sea of Tranquility in July 1969 and Apollo 17 touched down in the Taurus-Littrow highlands in December 1972. Thus, the astronauts' footsteps on the moon were foreshadowed by the prints their boots left in the soils of northern Arizona. In a very real sense, northern Arizona pointed us to the moon.

Once we reached the moon, a treasure trove of data about the origin, evolution, chemical nature, and place of the moon in the universe began to pour in. The questions about the origin of the lunar features were quickly answered in the light of what the moon rocks revealed. Moreover—though it was something hoped for but not vouchsafed at the time—we now are quite confident that we understand the origin of the moon itself.

The general public, needless to say, was captivated mostly by the horse race aspect. Once the goal had been reached, interest faded rapidly. On to other things! The politicians realized they would suffer little at the polls if they scaled Apollo back, and so it proved. The 24 missions originally intended were cut back to 17 by the Nixon administration, mainly because of budgetary pressures associated with the Vietnam War. Humans have not—at least bodily—returned to the moon since Apollo 17 returned to Earth in December 1972. Indeed, we are approaching half a century since the astronauts of Apollo 8 first captured the astonishing view of earthrise on Christmas 1968, and Neil Armstrong took "one small step for man, one giant leap for mankind." Almost as much time has passed since Apollo 11 as the interim between the moon landing in 1969 and the end of World War I.

In the lifetime of our frenetic and changing civilization, 50 years is a long time. Inevitably, the people associated with the moon program are passing away, and the sites associated with the training of astronauts and equipment, including the ones documented here, are fast fading from living memory.

This, then, is the background and motivation of the present book. We hope that it will contribute, in a small way, to preserve the memory of an era in which humans first left, in the words of the Russian space visionary Konstantin Tsiolkovsky, "the Earth, the cradle of humanity" and took their first small steps into the larger cosmos; steps, we argue, that were first taken in the otherworldly landscapes of northern Arizona.

We hope that, before the imprints of those footsteps are completely obliterated by the sands of time, fresh footsteps will be added and follow after.

One

METEOR CRATER

In 1891, the great US Geological Survey (USGS) geologist Grove Karl Gilbert visited the curious feature then known as "Crater Mountain" or "Coon Butte." Noting that a large number of meteorites had been found around the crater and intrigued by the rumor that it had been formed by a "falling star," Gilbert conducted field tests that led him to reject the hypothesis. Instead, he interpreted the feature as a "steam maar"—a feature created by a volcanically driven steam explosion. The meteorites, he thought, were a mere coincidence.

A few years later, a Princeton-educated mining engineer who had made a fortune from Arizona gold and silver mines became convinced that the crater had been formed by an iron-nickel meteorite that had buried itself beneath the crater floor. Daniel Moreau Barringer, for whom the crater was eventually named, was initially unaware of Gilbert's conclusion.

In 1903—with dreams of inconceivable fortunes— Barringer set up the Standard Iron Company in an attempt to find it. He sank numerous shafts. When he died in 1929, Barringer had failed to find the object of his obsession.

The reason for his failure would be demonstrated 30 years after his death by USGS geologist Gene Shoemaker. In a series of papers, the first of which was published in 1959, Shoemaker shows conclusively that only an extraterrestrial projectile could produce the enormous pressures evidenced in the crater. A meteorite, striking the target rock less than 50,000 years ago, had formed two interacting shock waves: The first had engulfed the meteorite and vaporized it (this is why Barringer could never find it), and the rest of the energy went on to produce a second shock wave traveling radially away from the point of impact, excavating the crater and throwing a rim of disintegrated material around it.

When the astronauts began training for the moon, Meteor Crater was, naturally, included on their itinerary. In January 1963, Shoemaker led a two-day training of nine astronaut recruits (the so-called Gemini group) about a feature that, rare on Earth, would prove to be ubiquitous on the moon. The geological training of the astronauts had begun.

Grove Karl Gilbert of the USGS made fundamental contributions to virtually every area of geology. In 1891, he traveled to Coon Butte after meteoritic iron was found there and tested whether the feature might have been formed by a "falling star." Famously, he concluded it was a maar—formed by a steam explosion. (Courtesy of the USGS.)

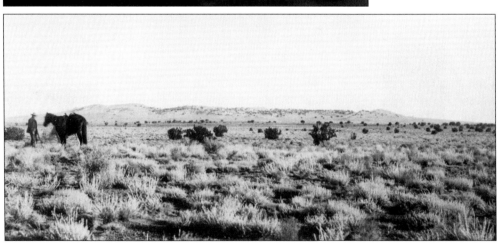

The view Gilbert saw on approaching Coon Butte from the south in 1891 is that which anyone traveling on Interstate 40 today still sees. Coon Butte appears as a less-than-impressive low-lying ridge against the horizon. The ridge is actually the rim formed by displacement of materials owing to the impact of the meteorite 50,000 years ago. (Courtesy of the USGS.)

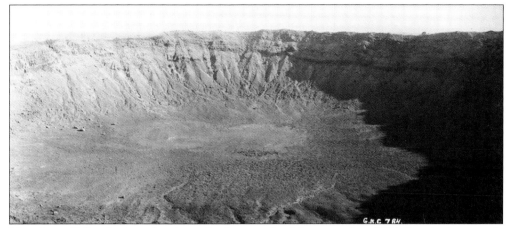

This shows Gilbert's original wide-angle photograph of the crater from 1891. Despite incorrectly concluding that the crater was formed by volcanically driven steam, a year later he correctly concluded, based on telescope observations with the US Naval Observatory (USNO) 26-inch refractor, that the craters of the moon were formed by meteorite impacts. (Courtesy of the USGS.)

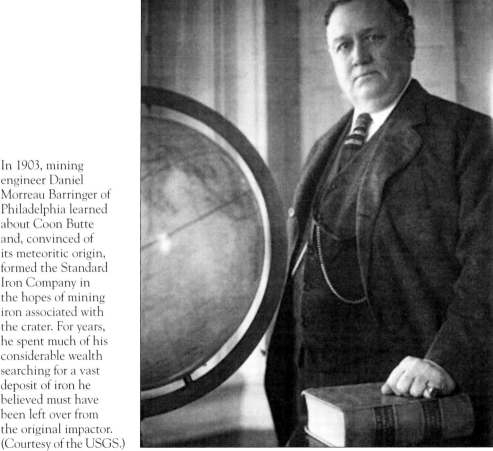

In 1903, mining engineer Daniel Morreau Barringer of Philadelphia learned about Coon Butte and, convinced of its meteoritic origin, formed the Standard Iron Company in the hopes of mining iron associated with the crater. For years, he spent much of his considerable wealth searching for a vast deposit of iron he believed must have been left over from the original impactor. (Courtesy of the USGS.)

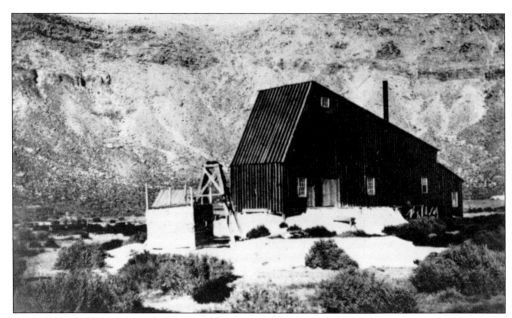

According to the 1906 article "Coon Mountain and Its Crater" by D.M. Barringer, this shows the shaft house on the floor of what became known to the public as Meteor Crater. As late as 1925, Barringer was still expecting to unearth 10 million tons of meteoritic material with a gross value, in 1925 dollars, of $500 billion. The meteorite was never found, and Barringer died penniless four years later. (Courtesy of the USGS.)

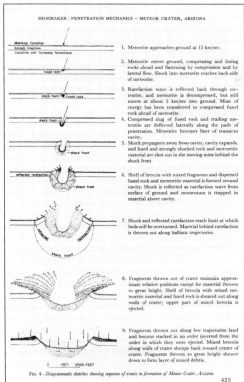

Geologist Gene Shoemaker went from studying nuclear bomb craters after World War II to studying Meteor Crater. In 1960, he proved its meteoritic origin and developed this diagram showing the stages of the impact process. The meteorite, for which Barringer had long searched in vain, was vaporized. Shoemaker's analysis of the origin of the crater became the prototype for understanding the process that formed many lunar craters. (Courtesy of the USGS.)

Working with geologist Edward Chao (left) of the USGS, Shoemaker discovered the first natural occurrence of the mineral coesite at Meteor Crater. Chemist Loring Coes had synthesized it in the lab, under extremely high pressures, in 1953. Since coesite could only be formed under high pressures, its natural occurrence at Meteor Crater indicated the chasm must have been created by a meteorite impact event. (Courtesy of the USGS.)

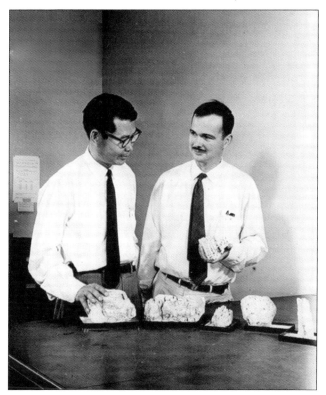

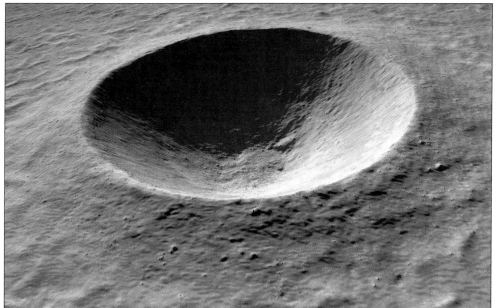

Linné is a fresh impact crater on the moon that became notable in 1866 when German astronomer Julius Schmidt claimed it underwent a significant change. It is now known that this was a mistake. Shoemaker realized that one of the best ways for astronauts to learn about such features on the moon was to study the best-preserved impact crater on Earth—Meteor Crater. (Courtesy of NASA.)

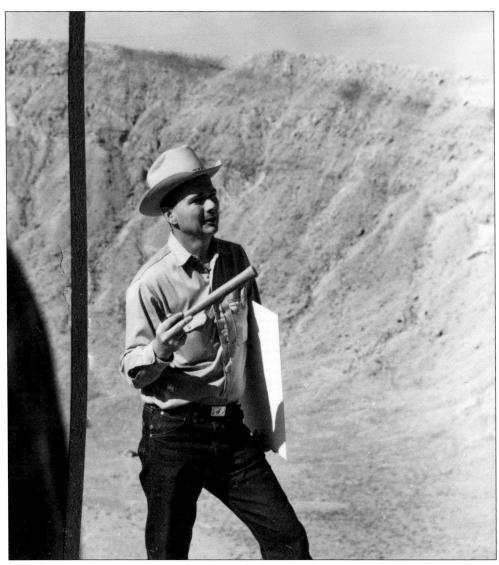

Since he was young, Gene Shoemaker dreamed of going to the moon. As he grew up and studied geology, this became a major goal for him. He earned his doctorate in geology from Princeton University in 1960, studying Meteor Crater for his dissertation. That same year, he founded the USGS Astrogeology Research Program in Menlo Park, California. Within a few years, he moved the program to Flagstaff in order to be closer to Meteor Crater and the area's rich array of volcanic rocks. As NASA began selecting astronauts with the ultimate goal of sending them to the moon, Shoemaker hoped to be selected to join this fraternity and thus fulfill his lifelong dream of exploring the lunar surface. He never realized the dream, disqualified from consideration due to Addison's disease. So, he did the next best thing—train those men chosen to be astronauts, helping them learn geology and ultimately traveling to the moon vicariously through them. The first place he took them was his old stomping grounds, Meteor Crater. (Courtesy of the Astrogeology Science Center, USGS.)

Some of the Meteor Crater training took place in the air, as Shoemaker and other geologists flew with astronauts in small planes over the crater and other geological features in northern Arizona in order to see them in the same manner as when they would fly to the moon. Most of the work, though, was at the crater, where Shoemaker and other geologists schooled the astronauts in geology. (Courtesy of the Astrogeology Science Center, USGS.)

The astronauts, dressed here in a variety of western hats, carry with them photographs and geological charts of Meteor Crater. With these resources, they explored the crater and learned how to recognize geological features—particularly related to the dynamics of impact cratering—and understand how they are depicted on maps. (Courtesy of the Astrogeology Science Center, USGS.)

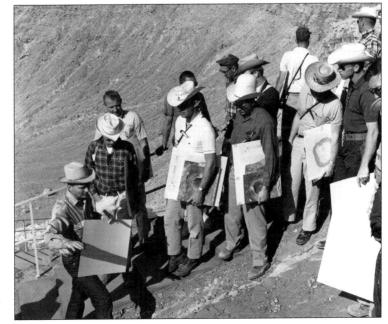

17

Flag Has Own Astronaut!

By WILLIAM HOYT

Dr. Harrison H. (Jack) Schmitt, 29-year-old Flagstaff astrogeologist, left by plane today for Houston, Texas, and the Manned Spacecraft Center there where Tuesday he will officially become one of America's first six scientist-astronauts.

The announcement, to be made at a press conference in Houston, will be something of an anti-climax as the names of the six scientists who will begin training next month for an eventual trip to the moon, were revealed unofficially last Saturday afternoon in Houston.

Schmitt, in Flagstaff when the premature word came, today declined immediate comment on his selection, explaining that he felt he should remain silent until MSC made it official.

The astrogeologist is scheduled to start a year's training as a jet pilot with three other newly-named scientist astronauts at Williams Air Force Base, Chandler, on July 29.

All six will be given intensive preparation to eventually ride, with other astronauts as "third man in the capsule" in a three-man Apollo spacecraft to the moon and to undertake scientific exploration and investigation of the earth's lone satellite.

The U.S. is working to launch the first manned Apollo lunar space flight sometime in 1970.

Schmitt and the other five scientists tabbed for the astronaut training program have had little to say since the premature word leaked out of their selection.

But in Flagstaff, the SUN learned that the handsome young geologist, has been working here since July, 1964, in the Branch of Astrogeology's Manned Lunar Exploration Studies division under division chief Donald Elston.

During the past year, he has headed up a special study project in the division designed to help determine the scientific priorities for experiments and researches to be performed by astronauts when they reach the moon.

A bachelor, he lives in a modest apartment at 709 West Grand Canyon in Flagstaff.

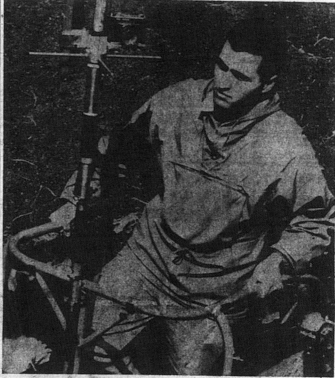

FLAGSTAFF'S OWN ASTRONAUT! — Astrogeologist Dr. Harrison H. (Jack) Schmitt of Flagstaff, named as one of the first six of the nation's scientist-astronauts, evaluates the use of several pieces of geological equipment on the lunar-like Bonita lava flow near Sunset Crater as part of his work here in the U.S. Geological Survey Branch of Astrogeology's lunar scientific studies. Schmitt, 29, has been working here since last July in the branch's Manned Lunar Exploration Studies division.

Slips in, Slips Out Again

Lynda Sees the Canyon,

But Very Few See Lynda

According to the June 28, 1965, issue of the *Arizona Daily Sun*, the first three classes of astronauts consisted of 30 test and/or fighter pilots and no scientists. By 1965, thanks to prodding by Shoemaker and others, NASA acknowledged the importance of sending scientists to space. In June of that year, NASA announced its newest class of astronauts, and all six were scientists, including three physicists, two physicians, and one geologist. This was big news in Flagstaff because that astronaut—Harrison "Jack" Schmitt—was employed at the USGS at the time. With a doctorate in geology from Harvard, Schmitt was familiar with the astronaut training program, since his job at the USGS had been to help develop geological procedures the astronauts would use on the moon. Schmitt would end up flying to the moon on the Apollo 17 mission, walking on the lunar surface with Gene Cernan. To date, he remains the only scientist to walk on another world. (Courtesy of Northern Arizona University, Cline Library.)

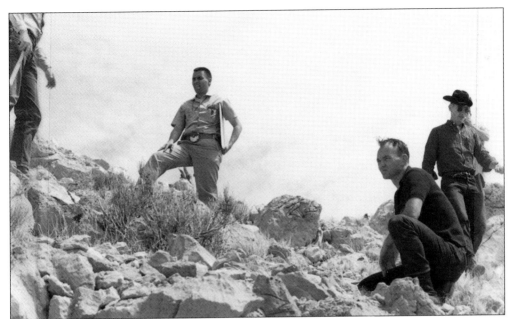

Jack Schmitt (third from right) trains at Meteor Crater with other astronauts, including Apollo 11's Michael Collins (kneeling, second from right). Schmitt was originally slated to fly aboard *Apollo 18*, but after NASA cancelled that mission due to budget cuts, officials—under pressure from the geology community to put a scientist onto the moon—moved him onto the Apollo 17 crew in place of Joe Engle. (Courtesy of the Astrogeology Science Center, USGS.)

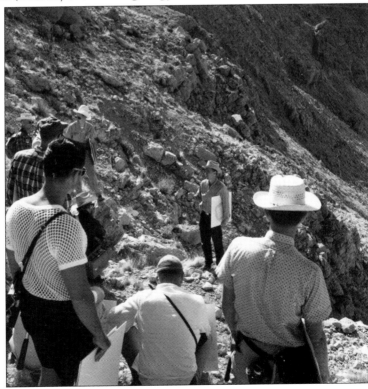

Gene Shoemaker, on the downside of the inner flank of Meteor Crater, trained astronauts not only here but also at other nearby geological features such as Sunset Crater. While both of them feature a central pit, the identity of Sunset Crater was never debated; early scientists easily recognized its volcanic origin. (Courtesy of the Astrogeology Science Center, USGS.)

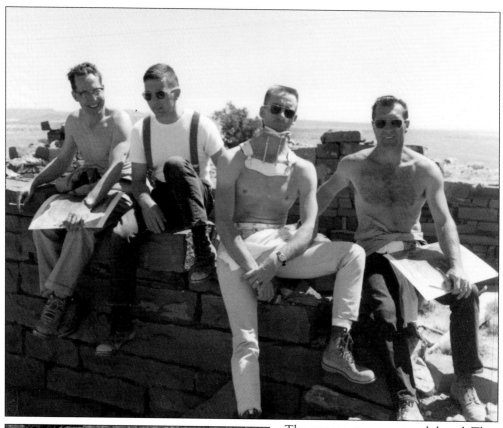

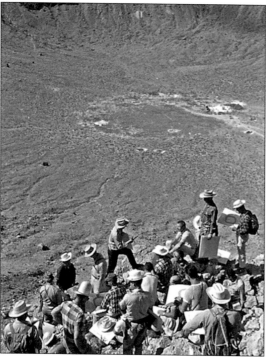

The astronauts were a tough breed. This photograph shows, from left to right, geologist Al Chidester and astronauts Bill Anders, Walt Cunningham, and Dick Gordon after they hiked out of Meteor Crater. Of particular interest here is Cunningham, who broke his neck just a week prior to this field trip. Wearing a brace, he refused to let the injury hold him back from fulfilling his astronaut duties. (Courtesy of the Astrogeology Science Center, USGS.)

Gene Shoemaker, hammer in hand, lectures to a group of astronauts in the mid-1960s. The site of Barringer's main mining operation is visible in the bottom of the crater, behind Shoemaker. While scientists today understand that little of the impactor remains, Meteor Crater is still a valuable resource, both as a scientific preserve and an educational center. (Courtesy of the Astrogeology Science Center, USGS.)

Two

A Grand Classroom

Arizona is called the "Grand Canyon State" for a reason. The northern part of the state contains one of the great natural wonders of the world, which Clarence Dutton of the US Geological Survey in 1882 called "by far the most sublime of all earthly spectacles."

In planning the geological study of the moon, Gene Shoemaker and the other geologists faced a challenge: how to interest the astronauts in their subject? A January 1963 expedition with nine astronauts—including Neil Armstrong—to interesting geological features around the town of Flagstaff went well and encouraged an even bolder attempt. Iwo Jima veteran and USGS geologist Dale Jackson agreed to take charge of two hikes with the astronauts into the Grand Canyon, on March 5–6 and March 12–13, 1964. The first involved 18 astronauts, including half of those who would walk on the moon. (On grounds they had not flown yet, the press refused to dignify any except veteran Mercury astronauts Alan Shepard and Scott Carpenter with the name *astronauts*.) The second hike involved another 10 astronaut recruits.

In small groups that included a geologist and two or three astronauts, the hikes began at South Kaibab Trail. The nights were spent at Phantom Ranch. The next day, the groups wound up Bright Angel Trail as far as Indian Garden and then the majority of participants carried on by mule back to the rim. The purpose was twofold: to inspire the astronauts' excitement for geology and to teach them some basic geological principles, such as the fact that young rocks lie on top of old rocks. With the exception of the famously skeptical Shepard, most of the astronauts were thoroughly inspired. Few, however, expressed it as well as future Apollo 11 astronaut Buzz Aldrin, who later wrote, "Geology opened my eyes to the immensity of time when . . . I found myself standing at the bottom of the Grand Canyon paying rapt attention as the instructor talked about things that took place eons before man existed on this earth."

On the surface of the moon, he did even better, calling the lunar surface a "magnificent desolation."

In the 1960s, Apollo astronauts hiked into the Grand Canyon for geological training on three different occasions: March 5–6, 1964; March 12–13, 1964; and June 2–3, 1966. The astronauts first flew into the Flagstaff airport, then drove the 70 miles north to the Grand Canyon for their hikes. Shown here at the airport is Alan Shepard (left) with Flagstaff mayor Rollin Wheeler. (Courtesy of the Astrogeology Science Center, USGS.)

Of the 18 astronauts participating in the March 5–6, 1964, hike, two were Mercury astronauts Alan Shepard and Scott Carpenter (right, with an unidentified group of people at the Flagstaff airport). Other astronauts included two from the second class, nicknamed the "Next Nine" (Neil Armstrong and Elliot See) and the entire group of 14 from the third class. (Courtesy of the Astrogeology Science Center, USGS.)

The March 12–13, 1964, training group consisted of 11 astronauts, including four from the original Mercury class and seven from the "Next Nine" group. Before they hiked into the Grand Canyon, geologists briefed them at what is today called the Yavapai Geology Museum. From left to right are Gus Grissom, John Young, Jim Lovell, Frank Borman, Pete Conrad, Uel Clanton, Wally Schirra, and Al Chidester. (Courtesy of the Astrogeology Science Center, USGS.)

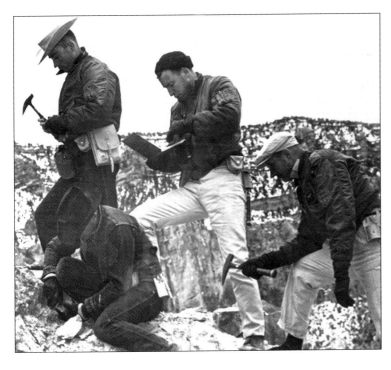

During training at the Grand Canyon, astronauts broke up into groups of three or four and worked with a geologist to learn field geology techniques. Astronauts pictured here are, from left to right, (kneeling) Pete Conrad; (standing) John Young, Jim Lovell, and Tom Stafford. (Courtesy of the Astrogeology Science Center, USGS.)

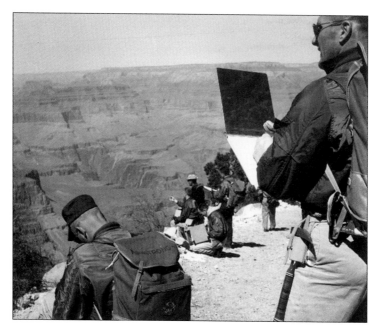

Astronauts Neil Armstrong (left) and Dick Gordon (right) record observations of the Grand Canyon. One goal of the Grand Canyon training was to familiarize the astronauts with geological principles such as superposition, which holds that, in an undeformed layer of rocks, the oldest ones are on the bottom, with each layer above being younger. (Courtesy of the Astrogeology Science Center, USGS.)

Like many people before and since, Neil Armstrong gazed across the expanse of the Grand Canyon and descended to the depths of the great chasm in search of knowledge and inspiration. Five years later, the soft-spoken engineer from Ohio became the first human to walk on another world, setting foot on the moon on July 20, 1969. (Courtesy of the Astrogeology Science Center, USGS.)

The geology training consisted of studying not only the rocks themselves but also photographs of the Grand Canyon. Geologist Al Chidester, in a white hat, looks on as an unidentified astronaut crouches down to examine a photograph with an optical device. A second astronaut, probably Ed White, looks on. (Courtesy of the Astrogeology Science Center, USGS.)

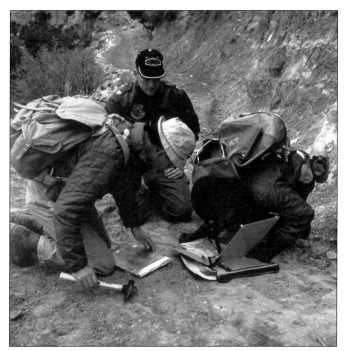

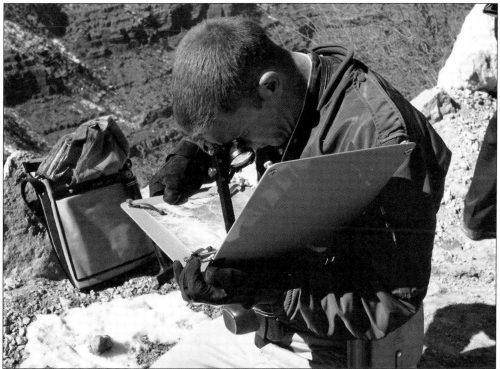

Here is a close-up view of astronaut Rusty Schweickart sitting near snow, looking at a picture through the optical device. The astronauts did this to familiarize themselves with large-scale geological features, such as they would see when trying to get their bearings as they prepared to land on the moon. (Courtesy of the Astrogeology Science Center, USGS.)

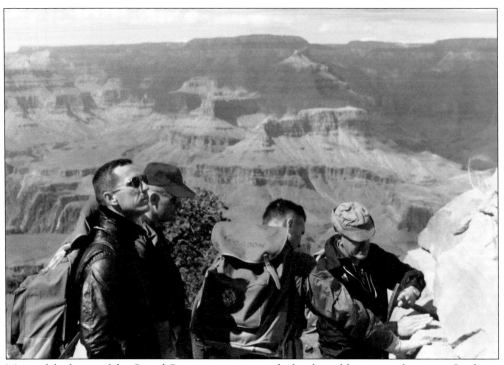

Many of the layers of the Grand Canyon are composed of rocks unlike any on the moon. Studying them was still useful for the astronauts because they were able to gain a general understanding of how rocks form and change over time. Shown here are, from left to right, Donn Eisele, Neil Armstrong, Dick Gordon, and geologist Dale Jackson. (Courtesy of the Astrogeology Science Center, USGS.)

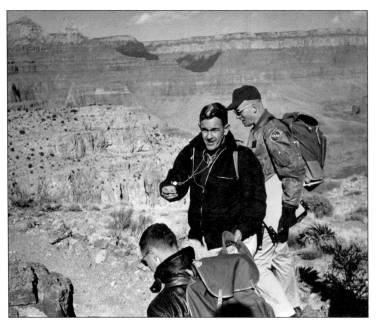

At the request of Gene Shoemaker, Dale Jackson (center) took charge of the astronaut training program in 1963 in order to add a geology component to the efforts. While Jackson stayed in this role for only a year, his efforts were critical in establishing geological training as a regular and dedicated component of overall astronaut training. (Courtesy of the Astrogeology Science Center, USGS.)

Astronauts listen to a geologist as they stand in snow at or near the top of the Grand Canyon. The lighter rock in the foreground is Kaibab Limestone, named in 1910 by geologist Nelson Horatio Darton after the Kaibab Plateau, which crops out on the north side of the canyon. (Courtesy of the Astrogeology Science Center, USGS.)

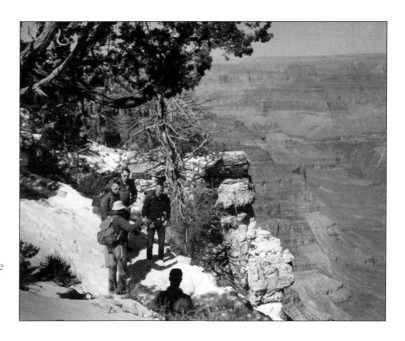

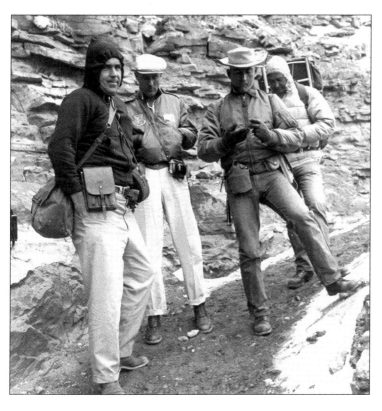

Geologists Jack McCauley (left) and Frank Letey (right) stand with astronauts Tom Stafford (second from left) and John Young (second from right), probably in The Chimney section of steep switchbacks at the top of the South Kaibab Trail on March 12, 1964. Frigid temperatures here eventually warmed as the group made its way down to the Colorado River. (Courtesy of the Astrogeology Science Center, USGS.)

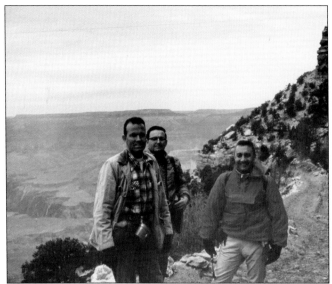

Mercury astronauts Gordon Cooper (left) and Gus Grissom (right) stand with geologist Ted Foss along the South Kaibab Trail, likely between The Chimney and Ooh Aah Point. Neither Cooper nor Grissom would ever fly to the moon; Grissom was tragically killed in 1967 during a ground-based test of Apollo 1, while Cooper retired from NASA in 1970. (Courtesy of the Astrogeology Science Center, USGS.)

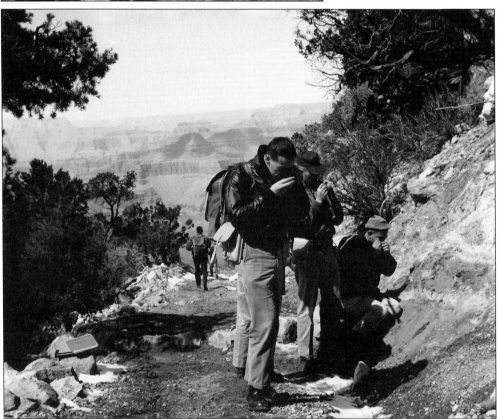

At the Grand Canyon, the astronauts studied geology's far-ranging scales, from the vast deposits of wedding-cake-like layers of rock to the minute mineral crystals that define different types of rock. In this scene along South Kaibab Trail, probably between The Chimney and Ooh Aah Point, expedition members use hand lenses to examine rocks. (Courtesy of the Astrogeology Science Center, USGS.)

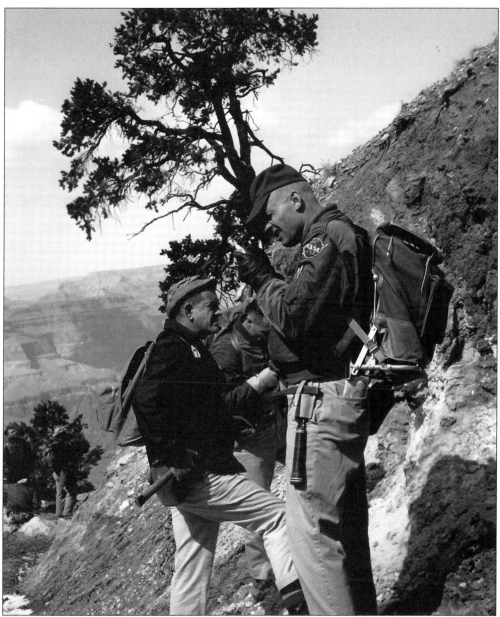

Geologist Dale Jackson (left) and Neil Armstrong (right) stand along the South Kaibab Trail during one of their many stops to examine the rocks. While Armstrong would never consider himself a real geologist—maybe an engineer who found geology interesting but not a true geologist—he did enjoy learning about geology and, by most accounts, performed his geological duties on the moon quite well. Like the majority of the other astronauts, he enjoyed the Grand Canyon experience and, for two days at least, looked the part of a geologist. As shown here, he wielded typical field equipment, including a hand lens, rock hammer, backpack for carrying supplies and rock samples, and, rolled up in his back pocket, an aerial photograph of the canyon. As Armstrong and his colleagues hiked through the canyon, they would try to identify their specific locations on these photographs—good practice for recognizing targeted landing sites when they flew to the moon. (Courtesy of the Astrogeology Science Center, USGS.)

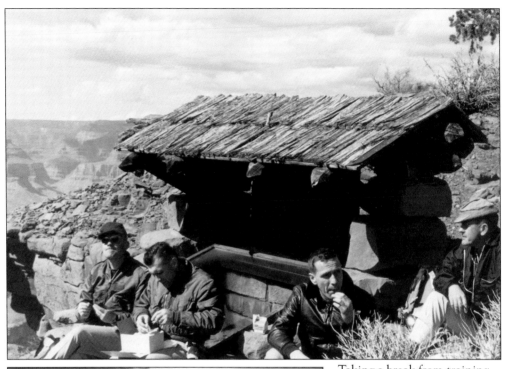

Taking a break from training to eat during their March 5–6, 1964, visit to the Grand Canyon are, from left to right, Neil Armstrong, Dick Gordon, Donn Eisele and geologist Dale Jackson. The group sits at the fossil fern exhibit at Cedar Ridge, along the South Kaibab Trail. (Courtesy of the Astrogeology Science Center, USGS.)

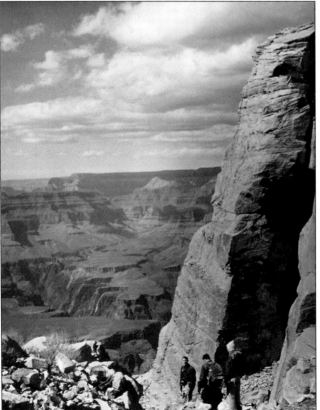

Astronauts and geologists stand along the South Kaibab Trail just above Ooh Aah Point. The large, vertical slab to the right of the frame is a distinctive feature composed of Coconino sandstone, a geological formation named for its presence in Coconino County, the second-largest county by area in the United States and home of the Grand Canyon. (Courtesy of the Astrogeology Science Center, USGS.)

Donn Eisele (left) and Dick Gordon (right) hike near O'Neill Butte, along the South Kaibab Trail. This prominent sandstone feature is named after Arizona legend Buckey O'Neill, who before dying during the Spanish-American War while serving as one of Theodore Roosevelt's Rough Riders, was a mayor, sheriff, newspaper editor, gambler, and prospector. (Courtesy of the Astrogeology Science Center, USGS.)

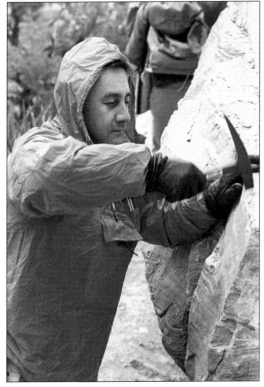

Gus Grissom, the second American in space, hammers at a rock during the March 12–13, 1964, excursion into the Grand Canyon. Grissom and his fellow astronauts were granted special permission for this activity. Normally, collecting rocks or other natural resources from national parks is strictly prohibited, but officials deemed preparing the astronauts for their moon voyages important enough to forego this regulation. (Courtesy of the Astrogeology Science Center, USGS.)

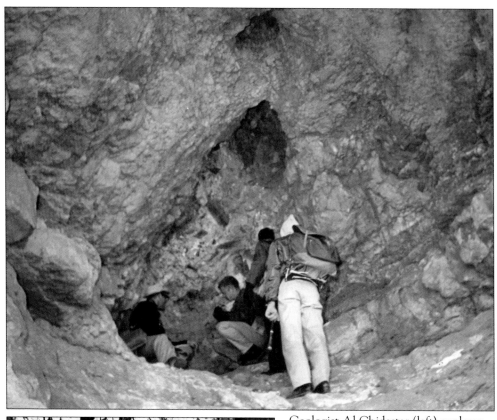

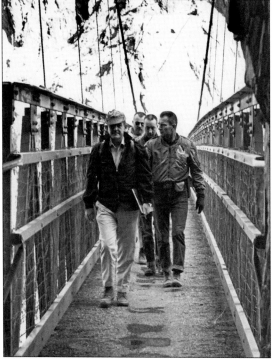

Geologist Al Chidester (left) explores a cavity in the rock with several astronauts. They are located along the South Kaibab Trail at the top of one of the switchbacks near Skeleton Point. A native of Illinois, Chidester was a leader in the development and coordination of the astronaut geology training. (Courtesy of the Astrogeology Science Center, USGS.)

Geologists Dale Jackson (left) and Verne Fryklund (second from left) join astronauts Jim McDivitt (third from left) and Deke Slayton (right) in crossing the Colorado River via the Black Bridge. Jackson played a key role in warming up the astronauts to the idea of geological training for their missions to the moon. (Courtesy of the Astrogeology Science Center, USGS.)

Ed White (left) and Jim Lovell stand below the Black Bridge, a suspension bridge that spans the Colorado River. Built in the 1920s, the Black Bridge is part of the South Kaibab Trail. Today, it is one of two bridges offering access from the South Rim to Phantom Ranch; the Silver Bridge, to the west, was constructed in the 1980s. (Courtesy of the Astrogeology Science Center, USGS.)

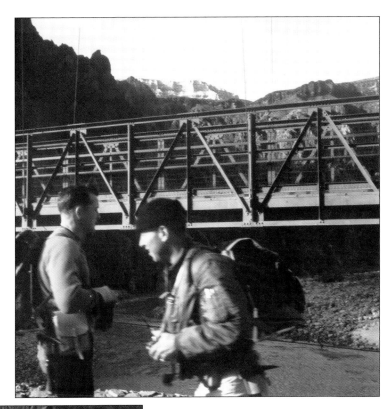

Jim Lovell, shown here near the Colorado River, was born in Cleveland, Ohio, and went on to become one of the most prolific early astronauts, flying on four missions between 1965 and 1970. He famously served as commander of the ill-fated Apollo 13 mission, dramatized in the 1995 film *Apollo 13*. (Courtesy of the Astrogeology Science Center, USGS.)

33

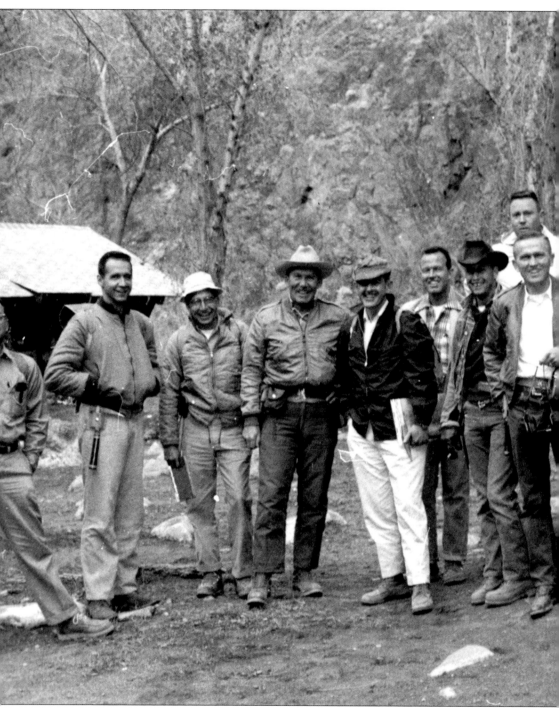

After a long day of hiking down the South Kaibab Trail and studying some of the canyon's rich geological heritage, the geologists and astronauts ate dinner and slept overnight at Phantom Ranch. Here, the March 12–13, 1964, group poses at this creekside oasis. From left to right are Ted Foss, Bryan Adams, Al Chidester, Wally Schirra, Dale Jackson, Gordon Cooper, Pete Conrad, Uel Clanton, Frank Borman, Jim Lovell, Gus Grissom, Ed White, John Young, Vern Fryklund,

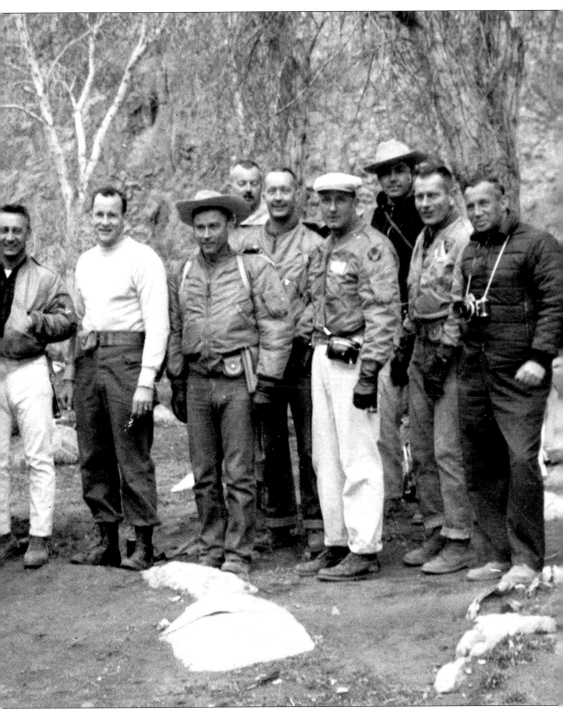

Jim McDivitt, Tom Stafford, Jack McCauley, Deke Slayton, and Al Chop. Like the March 5–6 group, this one spent the evening at Phantom Ranch after hiking down the South Kaibab Trail. The next morning, the men began the long climb out of the canyon via the Bright Angel Trail. (Courtesy of the Astrogeology Science Center, USGS.)

Ed White, one of the "Next Nine" group of astronauts that joined NASA in 1962, sits in front of the main Garden Creek ruin, between the Bright Angel Trail and Plateau Point. White went on to become the first American to walk in space but died in the 1967 *Apollo 1* fire that also took the lives of Gus Grissom and Roger Chaffee. (Courtesy of the Astrogeology Science Center, USGS.)

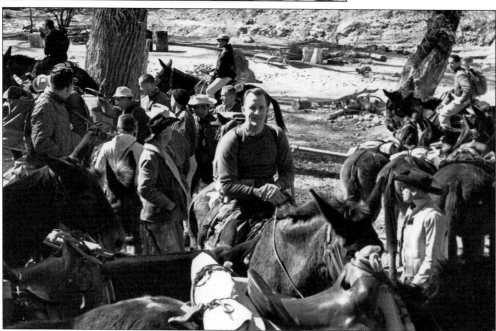

After hiking up Bright Angel Trail to Indian Gardens, most of the astronauts, including Ed White (in the center and looking at the camera), rode mules the rest of the way to the South Rim. A few, such as the ultracompetitive Alan Shepard, hiked out. (Courtesy of the Astrogeology Science Center, USGS.)

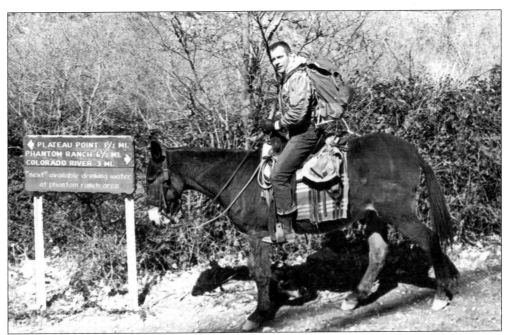

Deke Slayton, his backpack full of geology supplies, and likely some rocks, sits on a mule along the Bright Angel Trail near Indian Gardens. While Slayton never had the opportunity to fly to the moon and collect rocks there, he did finally get to space in 1975—at the age of 51—aboard the Apollo-Soyuz Test Project. (Courtesy of the Astrogeology Science Center, USGS.)

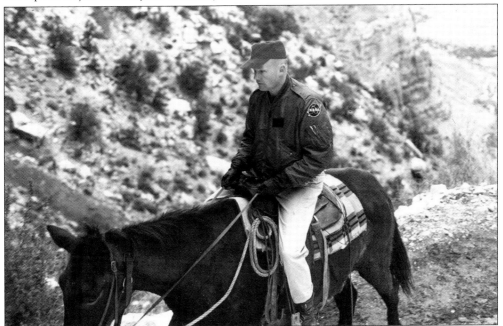

Neil Armstrong rides a mule out of the Grand Canyon on March 6, 1964. While Armstrong was an engineer by trade, he took a keen interest in learning geology and put the knowledge he learned to good use when he and Buzz Aldrin made the first moon landing in 1969. (Courtesy of the Astrogeology Science Center, USGS.)

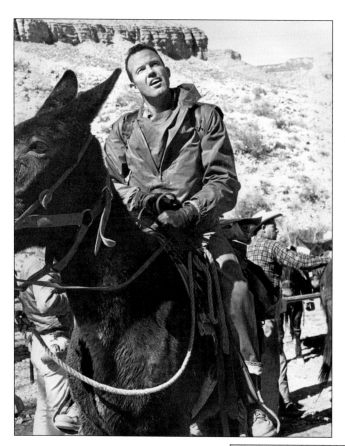

Mercury astronaut Gordon Cooper sits atop a mule before riding the last 4.9 miles out of the Grand Canyon on March 13, 1964. All of the Mercury astronauts trained in the Grand Canyon except one—John Glenn, who had retired from NASA early in 1964 to pursue a career in politics. (Courtesy of the Astrogeology Science Center, USGS.)

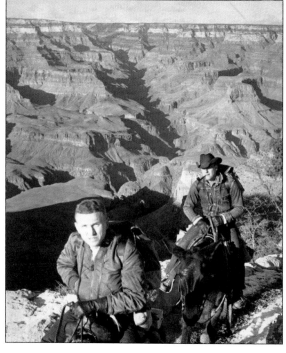

Pete Conrad (right) sports a cowboy hat and pipe as he follows future Apollo 12 crewmate Frank Borman up the Bright Angel Trail. After an overnight stay in the warmer depths of the Grand Canyon, the duo is back in the snow-dusted upper regions. Plateau Point, with its trail leading to a spectacular viewpoint of the Colorado River below, is behind Borman's head. (Courtesy of the Astrogeology Science Center, USGS.)

Three

CREATING CRATER FIELDS

Meteor Crater is an ideal terrestrial analog to the myriad of craters strewn across the lunar surface. Its well-preserved structure served as a perfect classroom for the astronauts to learn about the dynamics and morphology of impact cratering. Ninety-five miles to the northwest, the Grand Canyon also served as a useful geological training ground for the future moonwalkers, as much for its inspirational grandeur as for its variety of layered rocks.

Yet these two classic sites are just the beginning of the geological bonanza of northern Arizona. Roughly centered between the two is an 1,800-square-mile span of bumpy terrain called the San Francisco volcanic field. The area's assembly of 600 volcanoes and associated fields of cindery rubble was a perfect setting for testing equipment designed for the similarly rocky surface of the moon, as well as training the astronauts for their planned lunar activities.

One of the most critical issues the astronauts would encounter after reaching the moon was to pinpoint their location. They would have to be able to survey the landscape and identify craters and other topographic features as depicted on Lunar Orbiter photographs and maps created by Flagstaff scientists. If they were unable to do this, they would truly be lost on the moon.

Simply, the astronauts had to become experts at identifying topographic features, and this meant hours of training beforehand. USGS personnel found, or rather created, an ideal setting to carry this out. The youngest volcano in the San Francisco volcanic field is Sunset Crater, and cinders from its last eruption—in AD 1064—carpet the nearby terrain. Technicians buried and set off explosives in this cinder field, using images of a lunar landscape near Mare Tranquillitatis as a guide. The result was a simulated lunar surface that proved valuable not only crater for identification exercises but also for practice collecting geological samples, testing hand tools, and driving prototype rovers. Cinder Lake Crater Field, as it became known, proved quite useful and was later enlarged. Two additional fields—one adjacent to this first one and the other in Camp Verde—were later constructed.

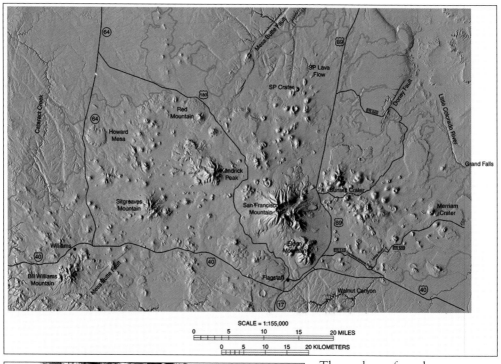

The geology of northern Arizona is dominated by the San Francisco volcanic field, which contains hundreds of volcanoes and is overlaid by a variety of lava flows and other deposits of rock similar to what geologists expected to find on the moon. These features made it an ideal place for training the moon-bound astronauts. (Courtesy of the Astrogeology Science Center, USGS.)

Beginning in 1963, astronauts began traveling to northern Arizona for geology training in the San Francisco volcanic field and beyond. In this April 30, 1964, photograph, geologist Dale Jackson (right) stands on a lava flow near Sunset Crater with, from left to right, astronauts C.C. Williams, Frank Borman, and Gene Cernan. (Courtesy of the Astrogeology Science Center, USGS.)

The Bonito Lava Flow was one of the more popular areas in northern Arizona for preparing to go to the moon. It originated from the eastern base of nearby Sunset Crater, which erupted sometime between 1040 and 1100. Geologists tested new equipment here, and astronauts (including the one just visible here) practiced their lunar excursions on the flow's blocky surface. (Courtesy of the Astrogeology Science Center, USGS.)

Astronaut Jack Schmitt, loaded down with a pack, photograph, and other equipment, surveys the Bonito Lava Flow during a training exercise. Schmitt was a member of the fourth astronaut group and the first that consisted of scientists rather than pilots. Four of the six class members would eventually fly in space, though Schmitt was the only one to go to the moon. (Courtesy of the Astrogeology Science Center, USGS.)

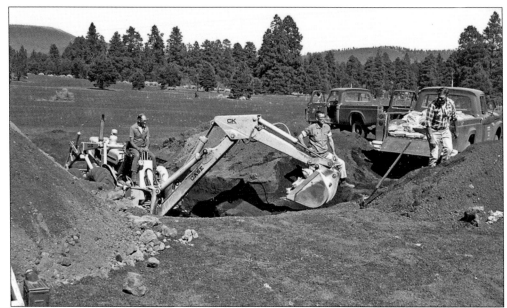

Within a few miles of the Bonito Lava Flow is a large, flat cinder field, another product of the Sunset Crater eruption. In July 1967, geologists used this site to create a simulated lunar surface, complete with a network of craters modeled after real ones on the moon. Here, a USGS team digs holes for setting explosive charges. (Courtesy of the Astrogeology Science Center, USGS.)

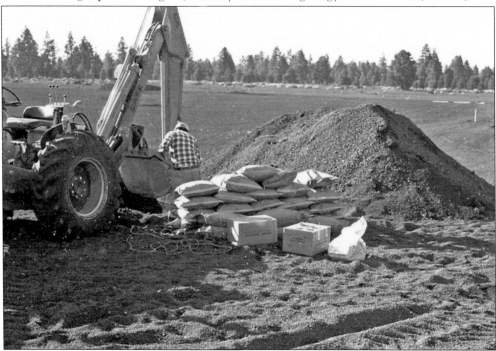

The USGS team, led by Norman "Red" Bailey, filled the holes with a combination of ammonium nitrate and dynamite. These charges were connected with detonating cord so that they could be exploded simultaneously. The team then covered the explosives with cinders and graded the entire 250,000-square-foot area of filled holes. (Courtesy of the Astrogeology Science Center, USGS.)

When the team exploded the charges, cinders and dust dramatically flew into the air in much the same way as would happen if rocks from space impacted Earth. Gene Shoemaker, always trying to understand crater dynamics, asked the team to bury the leftover explosives and generate another large explosion (shown here). (Courtesy of the Astrogeology Science Center, USGS.)

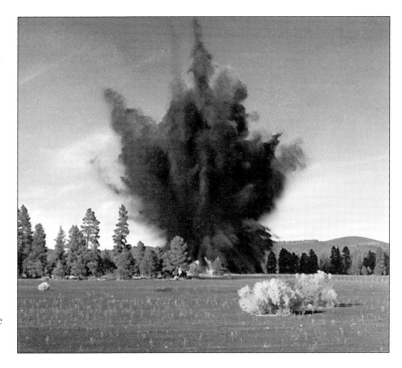

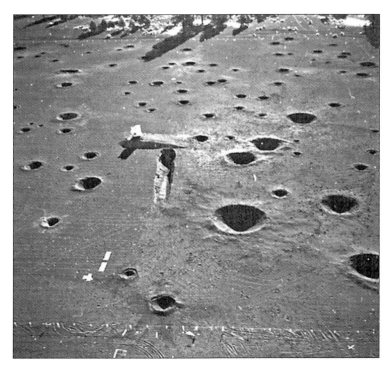

After dust from the explosion settled, 47 new craters dotted the landscape. As planned by the USGS team, the craters were of different sizes and depths, matching the dimensions of the actual lunar craters on which this simulated group was based. Also visible in this picture is a ramp of dirt topped by a lunar module mock-up. (Courtesy of the Astrogeology Science Center, USGS.)

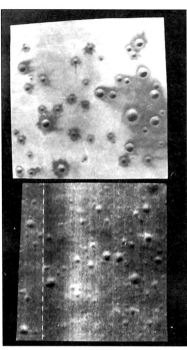

Geologists dubbed the simulated lunar surface they had created Cinder Lake Crater Field. This image shows that it compared quite favorably with the actual area on the moon's surface on which it was based. The top section shows the new crater field, while the bottom is from a Lunar Orbiter photograph of the moon's Mare Tranquillitatis. (Courtesy of the Astrogeology Science Center, USGS.)

In early October, Red Bailey and his crew enlarged Cinder Lake Crater Field, again digging holes and setting charges to create 96 additional craters. The area of the field now measured 640,000 square feet and proved a reasonable analogy to the moon for astronaut training and the development of instruments. (Courtesy of the Astrogeology Science Center, USGS.)

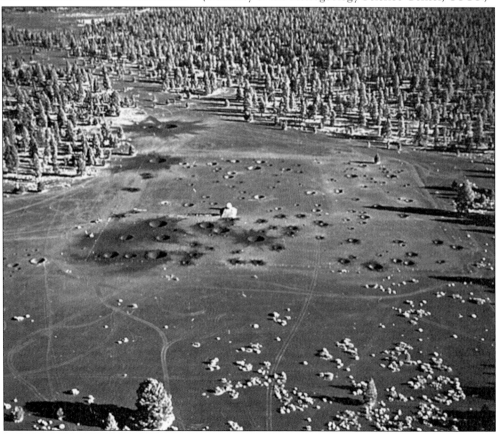

One of the main reasons for creating Cinder Lake Crater Field was to give astronauts a place to practice identifying lunar features, particularly craters. This skill would be critical in pinpointing their location once they reached the lunar surface. To help in this effort, geologists created this photogeologic map of the field. (Courtesy of the Astrogeology Science Center, USGS.)

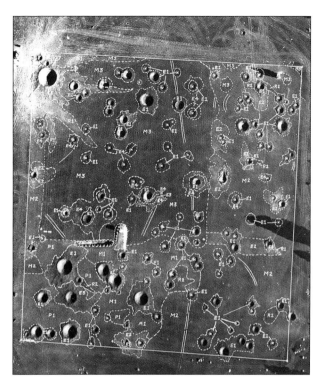

In July 1968, the USGS decided to create an additional simulated crater field in order to expand the mission planning and training efforts. This picture shows the dramatic explosion that created this new field, with cinders flying high against the backdrop of the San Francisco Peaks. (Courtesy of the Astrogeology Science Center, USGS.)

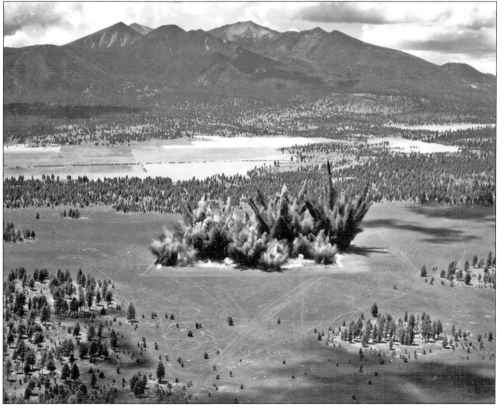

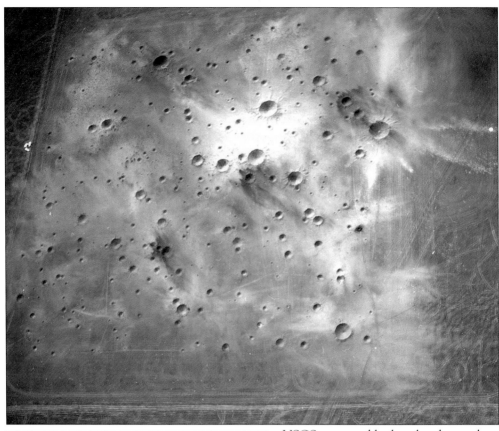

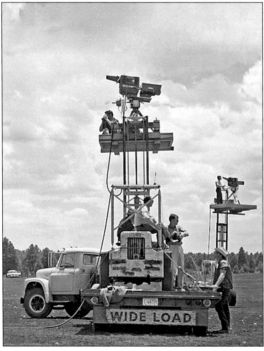

USGS personnel had explored several sites where they would create the new field, including a lava flow adjacent to the storied SP Crater, just north of Flagstaff. They ultimately decided to locate it next to the original crater field, which then became known as Cinder Lake Crater Field 1, while the new area, shown here, was called Cinder Lake Crater Field 2. (Courtesy of the Astrogeology Science Center, USGS.)

On July 16, 1969, astronauts Neil Armstrong, Buzz Aldrin, and Mike Collins blasted off from Earth on the Apollo 11 mission, which culminated with Armstrong taking the first steps by a human on another world. Back in Flagstaff, CBS camera crews set up equipment at the Cinder Lake Crater Field complex and presented live broadcasts throughout the mission. (Courtesy of the Astrogeology Science Center, USGS.)

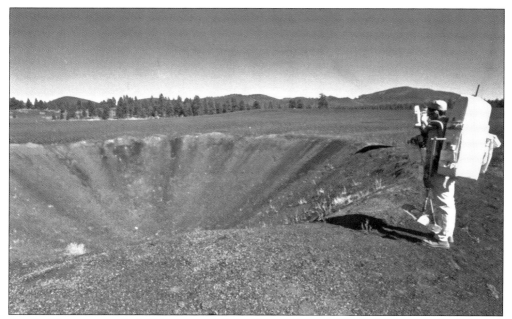

Apollo 17 astronauts Jack Schmitt and Gene Cernan (mostly blocked from view by Schmitt) familiarize themselves with one of the craters at the Cinder Lake Crater Field complex. They examined the structure of the crater and described their observations, all activities they would do once on the lunar surface. (Courtesy of the Astrogeology Science Center, USGS.)

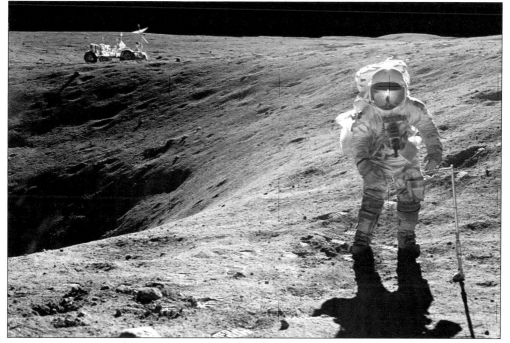

As a comparison to the previous picture, Apollo 16 astronaut Charlie Duke carries out an experiment next to a lunar crater in the moon's Descartes Highlands area, west of Mare Nectaris. Training at the Cinder Lake Crater Field prepared Duke and his fellow astronauts for such efforts. (Courtesy of NASA.)

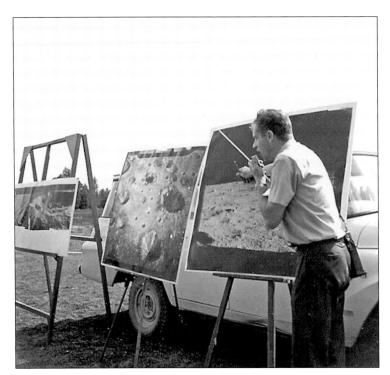

USGS geologist Gordon Swann gives a briefing at the Cinder Lake Crater Field complex. Swann led several of the geology field trips and training exercises for the astronauts and developed many of the geological procedures—including those using geology hammers to collect lunar rocks—that the astronauts would use on the moon. (Courtesy of the Astrogeology Science Center, USGS.)

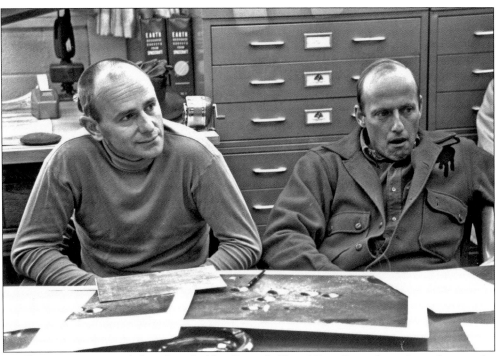

Apollo 12 astronauts and close friends Alan Bean (left) and Pete Conrad are shown here at the USGS Flagstaff headquarters a month before their November 1969 flight to the moon. Geologists briefed them at headquarters before they headed to the Cinder Lake Crater Field complex for some last-minute training. (Courtesy of the Astrogeology Science Center, USGS.)

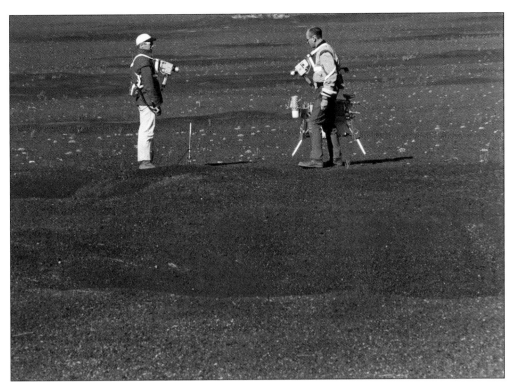

Pete Conrad (left) and Alan Bean practice the geology activities they will carry out on the moon the following month. Bean said years later, "Flagstaff was the beginning of my journey into learning and understanding the world of geology. I now love geology, thanks to these early experiences in Flagstaff." (Courtesy of the Astrogeology Science Center, USGS.)

The Cinder Lake Crater Field complex had one significant drawback: During the winter, temperatures could be quite cold, and snow would cover the area. Geologists thus decided to create another, more southerly, field, 60 miles southwest of Flagstaff in the Verde Valley. Here, geologist Bob Philpott prepares explosives that will be used to make the field. (Courtesy of the Astrogeology Science Center, USGS.)

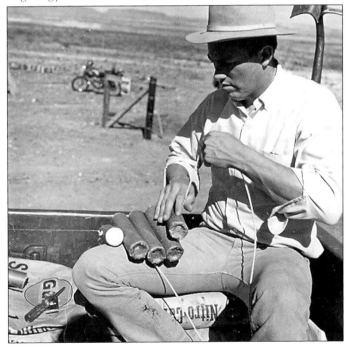

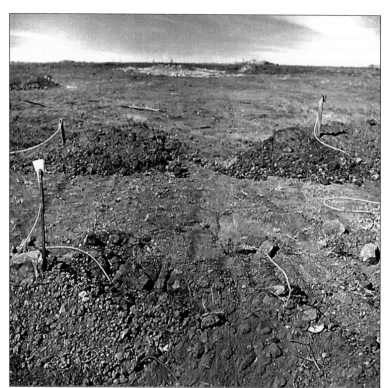

Below the mounds of cinders and network of primer cord lie the buried explosives that geologists will detonate to create the Black Canyon Crater Field near Cottonwood, Arizona. They did this in February 1970 and produced a new 35-acre training site with some 380 craters. (Courtesy of the Astrogeology Science Center, USGS.)

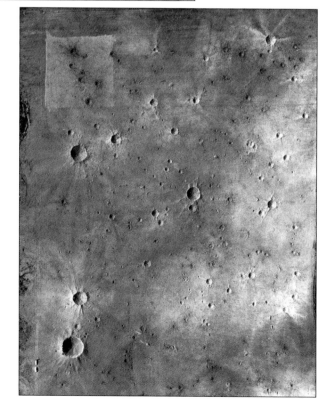

The Black Canyon Crater Field contained craters ranging in size from 6 to 82 feet. For a short time, it was a valued area for astronaut training, with four of the future moonwalkers training there. Today, the site is just a memory, as the craters have been covered over and topped by buildings. (Courtesy of the Astrogeology Science Center, USGS.)

Apollo 13 astronauts Jim Lovell (left) and Fred Haise (right) talk with a geologist during a March 1970 training exercise at the Black Canyon Crater Field. The crew prepared to explore the Fra Mauro Highlands on the moon but never got the chance because of a problem with their spacecraft that prevented them from landing on the moon. (Courtesy of the Astrogeology Science Center, USGS.)

While the Black Canyon Crater Field was used primarily in winter months, the more convenient Cinder Lake Crater Field complex in Flagstaff was in constant use during the rest of the year. Here, stylishly dressed astronaut Gene Cernan practices for his lunar excursion at the Flagstaff location. (Courtesy of the Astrogeology Science Center, USGS.)

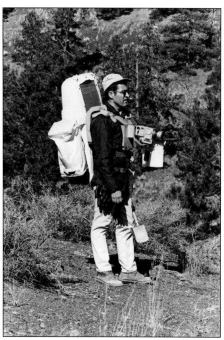

Gene Cernan was the last human to stand on the moon, which he did as part of the final manned lunar flight, Apollo 17. His fellow moonwalker was Jack Schmitt, shown here at the Cinder Lake Crater Field complex. While Cernan, a fighter pilot, was one of the old guard astronauts, he worked well with Schmitt, the geologist, during their December 1972 mission. (Courtesy of the Astrogeology Science Center, USGS.)

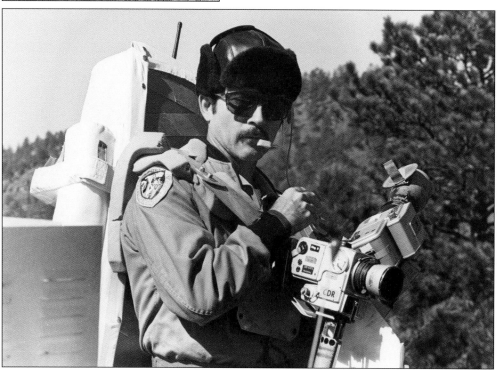

Astronaut John Young communicates with a simulated control while training at the Cinder Lake Crater Field complex. Young circled the moon, along with Gene Cernan and Tom Stafford, on the Apollo 10 mission. He eventually was able to put his northern Arizona geology training to good use when he walked on the moon during the Apollo 16 mission. (Courtesy of the Astrogeology Science Center, USGS.)

Apollo 17 astronauts Gene Cernan (left) and Jack Schmitt practice collecting rocks at the Cinder Lake Crater Field complex. Originally, Joe Engle was to fly on the mission as the lunar module pilot, but administrators finally gave in to the idea of sending a scientist to the moon and bumped Engle in favor of Schmitt. (Courtesy of the Astrogeology Science Center, USGS.)

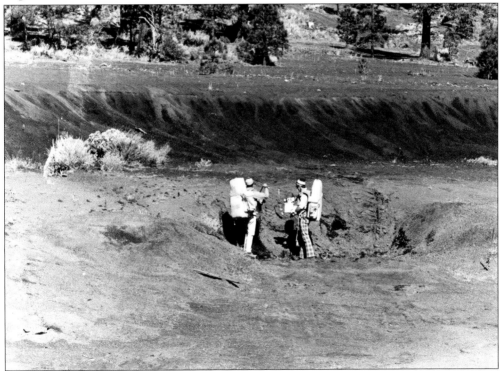

While on the moon, the astronauts had a full slate of planned activities and could not afford to waste much time. They had to practice every aspect of their missions ahead of time, over and over, so that all of it was second nature once they reached the moon. Here, Jack Schmitt (left) collects a sample, while Gene Cernan films the effort. (Courtesy of the Astrogeology Science Center, USGS.)

If accomplishments serve as any sort of indicator, Gene Cernan (center) and Jack Schmitt (right) were pretty serious and driven individuals. Cernan was a veteran space traveler, flying aboard *Gemini 9a* and *Apollo 10*. He had a bachelor of science degree in electrical engineering, a master of science in aeronautical engineering, and 5,000 hours of flying time as a Navy aviator and fighter pilot. For his part, Schmitt had a PhD in geology, with thousands of hours of geological fieldwork. He would later serve as a US senator from New Mexico. In 1972, they would team up with Ron Evans to fly on the Apollo 17 flight to the moon. While Evans circled the moon, mission commander Cernan and lunar module pilot Schmitt would get out and take a walk, the last humans to set foot on a foreign world. Here, the pair enjoys a moment of levity during a geology training session at the Cinder Lake Crater Field complex. (Courtesy of the Astrogeology Science Center, USGS.)

Four

TRAVELING ON THE MOON

The goals of the early Apollo moon flights were simple: Fly to the moon, plant the flag, collect a few rocks, and get back home safely. They were mostly technological affairs that kept engineers busy designing adequate rockets, spacecraft, suits, and other equipment necessary to safely transport astronauts across the hazardous voids of space and allow them to spend a bit of time on the moon.

However, even before Neil Armstrong first stepped onto the lunar surface on July 20, 1969, planners were looking down the road, gearing up for more ambitious flights for project Apollo and beyond. Scientists were making their voices heard with demands of scientific exploration that would help unravel some of the mysteries of the moon, from its origins to its internal structure.

One aspect of these expanded efforts involved travel on the moon. Planting a flag and collecting some samples was easily accomplished on foot, but true geology fieldwork meant astronauts would have to travel greater distances. This would require a means of not only transporting the astronauts but also carrying equipment for surveying, rock collecting, communicating with Earth, and filming, as well as schlepping specimens they collected.

The need for some sort of powered vehicle was driven home on the Apollo 14 mission, when astronauts Alan Shepard and Edgar Mitchell struggled to pull a hand-operated cart around the lunar surface. The device was clearly inadequate for this mission, let alone the later ones that would require much longer traverses.

While engineers tested a variety of powered vehicles, including a jetpack that would allow astronauts to fly, they ultimately narrowed the list down to a rover, a wheeled vehicle that astronauts would drive across the moon. Three companies submitted proposals and built prototypes, all of which were tested in the cinder fields around northern Arizona. Planners eventually went with a sort of space-age dune buggy, characterized by a large communication dish and wire mesh wheels. While this rover was developed, planners continued working on other alternatives for potential post-Apollo missions, resulting in a diverse fleet of lunar vehicles.

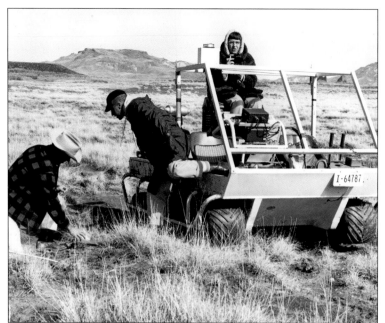

Geologists and astronauts used this eight-wheeled vehicle, called the *Trespasser*, for field testing a variety of instruments and tools. In this November 1966 image, astronauts Joe Engle (left) and Paul Weitz (center) work with USGS staffer Kenna Edmonds at Hopi Buttes volcanic field in eastern Arizona. (Courtesy of the Astrogeology Science Center, USGS.)

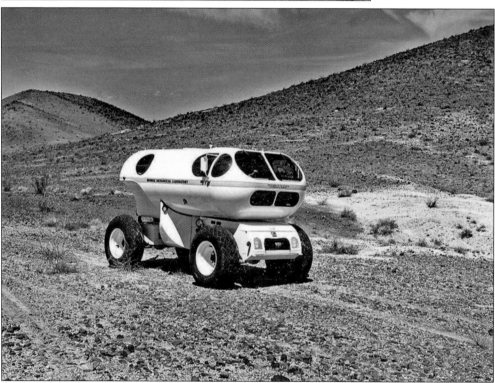

In the mid-1960s, NASA contracted with General Motors to build this vehicle prototype for potential extended lunar missions. Known as *MOLAB* (MObile LABoratory) or *MGL* (Mobile Geological Laboratory), it was never flown to the moon but was used for a variety of activities in northern Arizona related to the development of instruments and equipment used on the manned moon missions. (Courtesy of the Astrogeology Science Center, USGS.)

MOLAB weighed 8,200 pounds and stood 20 feet tall. It was designed to accommodate two astronauts for up to two weeks, or three astronauts for a shorter period. It also served a rather unusual purpose, as shown in this image, when CBS camera crews carried live broadcasts from its roof. (Courtesy of the Astrogeology Science Center, USGS.)

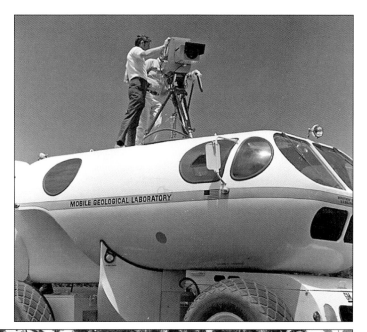

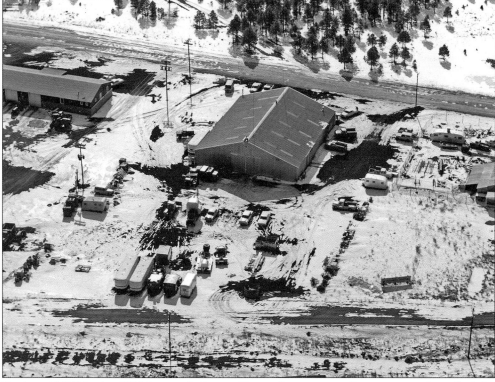

By the mid-1960s, the USGS main facility in Flagstaff was too small to accommodate all of the staff needed for carrying out the various moon-related activities. The USGS thus rented buildings around town, including this one at 1980 East Huntington Road. Here, machinists built the first of two vehicles used for developing lunar exploration techniques and training the astronauts. (Courtesy of the Astrogeology Science Center, USGS.)

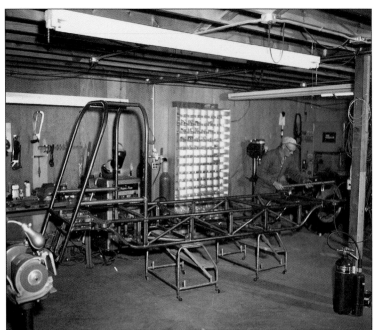

Technician Dick Wiser, shown here, worked with Rutledge "Putty" Mills and Bill Tinnin at the Huntington Road facility to build *Explorer*, a four-wheel-drive vehicle that would see a lot of action in the cinder fields around northern Arizona. Wiser, father of Flagstaff historian Sherry Mangum, works on the chassis in this image. (Courtesy of the Astrogeology Science Center, USGS.)

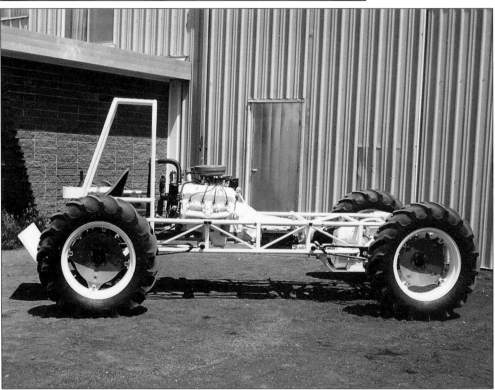

Here is *Explorer* just after Putty Mills, Dick Wiser, and Bill Tinnin finished building it. The vehicle sat high off the ground and could be driven from either end. Steering, which was done with a joystick mounted onto a control console, featured both manual and electric options. (Courtesy of the Astrogeology Science Center, USGS.)

Against the backdrop of the San Francisco Peaks, technicians test drive *Explorer* at the Cinder Lake Crater Field complex. From left to right are Dick Wiser, John Hendricks, Bill Tinnin, and Putty Mills. The vehicle maneuvered well in the cinders and proved an important tool for geological fieldwork and testing. (Courtesy of the Astrogeology Science Center, USGS.)

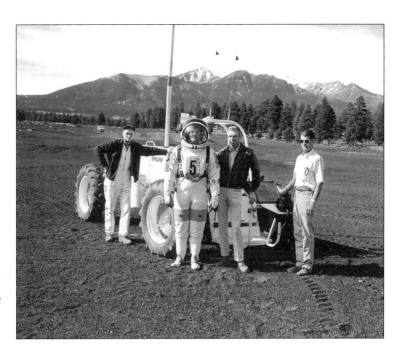

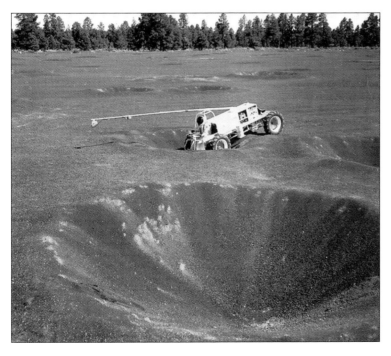

This image shows several of the man-made craters that make up the Cinder Lake Crater Field complex and give it a reasonably authentic lunar appearance. A driver has taken the fully equipped *Explorer* into one of the craters to test its maneuverability and ability to pull itself out of trouble. The long boom extending from *Explorer* holds a magnetometer. (Courtesy of the Astrogeology Science Center, USGS.)

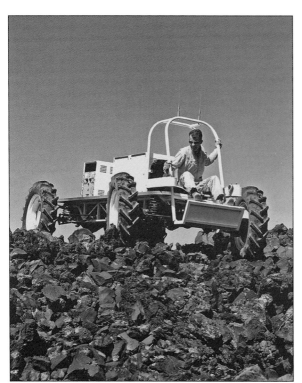

Putty Mills carefully steers *Explorer* over the rubbly lava flow of SP Crater, located 25 miles north of Flagstaff. The crater is an 800-foot-high cinder cone volcano in the San Francisco volcano field, and its lava flow stretches several miles to the north. (Courtesy of the Astrogeology Science Center, USGS.)

In January 1969, the National Geographic Society visited Flagstaff to document USGS field tests at the Cinder Lake Crater Field complex. Technicians brought out both *Explorer* and *MOLAB* to demonstrate their capabilities. *Explorer* was in full test mode, with the driver wearing a space suit and the magnetometer in operation. (Courtesy of the Astrogeology Science Center, USGS.)

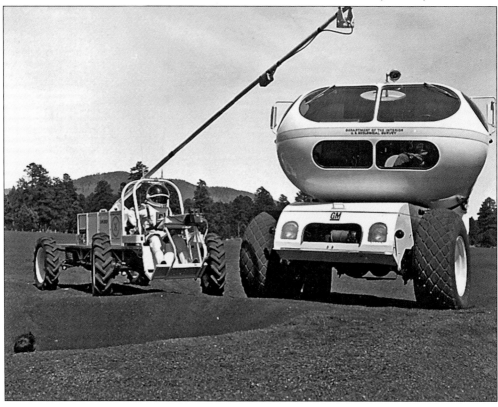

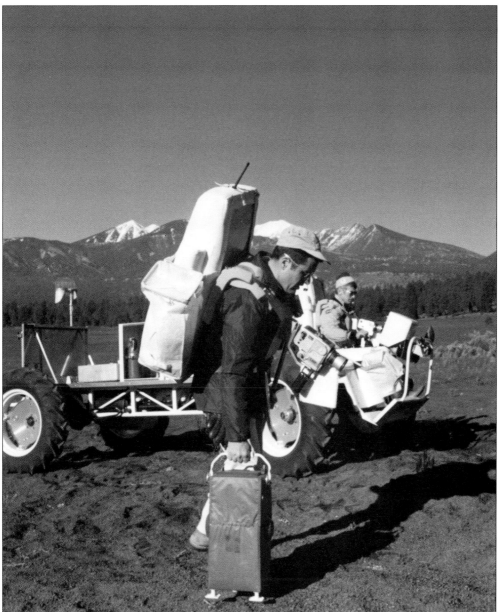

During one of their training sessions at the Cinder Lake Crater Field complex, Apollo 17 astronauts Jack Schmitt (left) and Gene Cernan used *Explorer* to carry equipment and traverse the moonlike surface. The snow-covered San Francisco Peaks made for a pretty and distinct working environment. While astronaut training in this area is long over, many of the man-made craters still survive, despite decades of natural weathering and erosion from wind and rain, as well as human-induced deterioration from dune buggies and other recreational vehicles driven over the surface. NASA has, however, sent modern-day astronauts to other artificial crater fields and volcanic areas in northern Arizona for training. Perhaps future explorers of Mars or the moon will also hone their skills here, driving futuristic rovers, collecting age-old samples, and surveying the terrain as practice for recognizing geological features on other worlds. (Courtesy of the Astrogeology Science Center, USGS.)

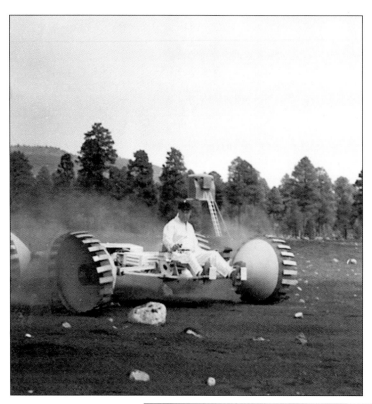

In September 1969, NASA was preparing for the later moon missions that would include long traverses requiring a vehicle to transport the astronauts, their equipment, and rock samples. That month, NASA tested three different prototype Lunar Roving Vehicles (LRVs) at the Cinder Lake Crater Field complex, including this one built by Grumman Aircraft. (Courtesy of the Astrogeology Science Center, USGS.)

Astronaut Jack Schmitt (right) and an unidentified passenger test a second LRV prototype, built by Bendix Aerospace. Except for the special tires designed to travel over loose sediment, the vehicle looks more like an old Sears motor buggy than a lunar excursion vehicle. (Courtesy of the Astrogeology Science Center, USGS.)

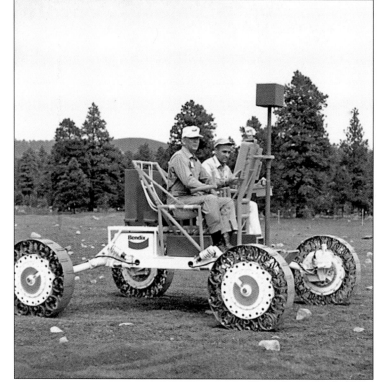

Boeing and General Motors teamed up on the third LRV prototype, which officials ultimately selected as the one to go to the moon. In 1970, at the request of NASA, USGS machinists in Flagstaff built a training vehicle roughly based on the LRV blueprints. Putty Mills, shown here, and others carried out this effort in another rented building at 1724 East Street. (Courtesy of the Astrogeology Science Center, USGS.)

USGS staff soon referred to the LRV trainer as *Grover*, for geological rover. It would be used in the Flagstaff cinder fields and elsewhere by astronauts training for the Apollo 15, 16, and 17 missions. Here, Bill Tinnin (left) and Dick Wiser tinker with one of *Grover*'s wheels. (Courtesy of the Astrogeology Science Center, USGS.)

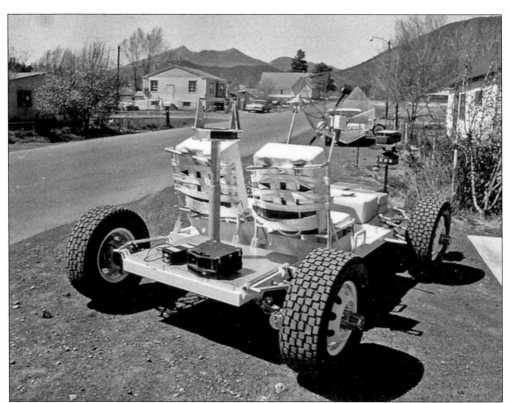

Here is the finished version of *Grover*, seen in a view looking north from the parking lot of the East Street facility. As seen here, the facility was in a mostly residential area. In the background to the upper left are Flagstaff's iconic San Francisco Peaks, while the nearer Mount Elden is visible at upper right. (Courtesy of the Astrogeology Science Center, USGS.)

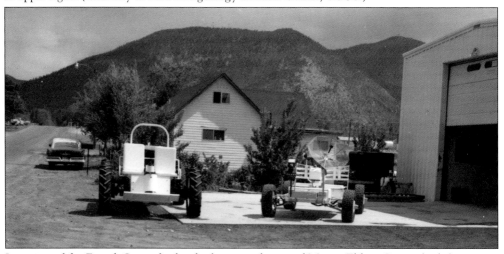

In a view of the Fourth Street facility looking north toward Mount Elden, *Grover* (right) sits next to *Explorer*. *Grover* was a workhorse training vehicle for astronauts of the so-called J missions (NASA identified several types of Apollo moon missions, such as G, first moon landing—Apollo 11; H, precision landings and moonwalks for Apollos 12–14; and J for longer stays and LRV use—Apollos 15–17.) (Courtesy of the Astrogeology Science Center, USGS.)

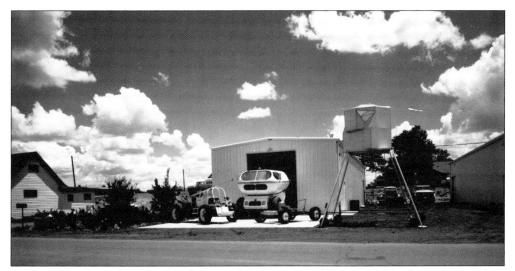

By the early 1970s, the USGS had accumulated quite a collection of vehicles and equipment for developing moon mission procedures and training astronauts. Staff assembled many of them here for a family photograph, including, from left to right, *Explorer*, *MOLAB*, *Grover* while still under construction, and a lunar module mock-up. (Courtesy of the Astrogeology Science Center, USGS.)

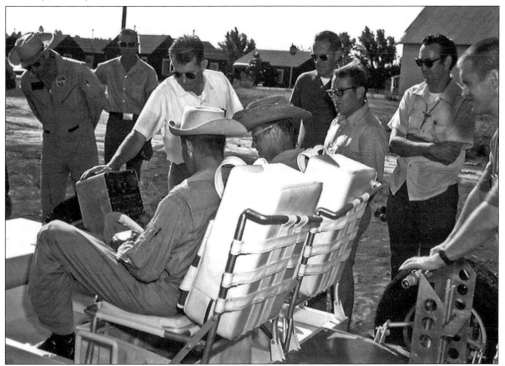

On September 2, 1970, the prime and backup crews of Apollo 16 visited Flagstaff's East Street facility. Here, Putty Mills (standing, third from left) briefs astronauts John Young (standing, far left), Fred Haise (sitting in the left seat), Gerald Carr (sitting in the right seat), Charlie Duke (standing, fourth from right), and Tony England (standing, far right). The rest are unidentified. (Courtesy of the Astrogeology Science Center, USGS.)

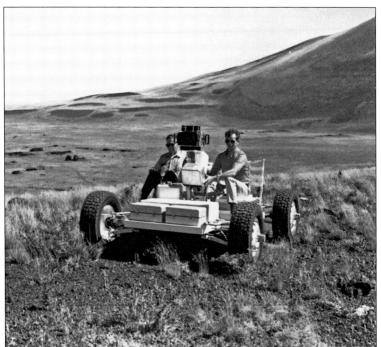

Putty Mills (right) and an unidentified passenger aboard *Grover* test a Hycon camera (mounted between them) during a field test north of Flagstaff. Merriam Crater, one of the larger cinder cones in the San Francisco volcanic field, looms to the right. (Courtesy of the Astrogeology Science Center, USGS.)

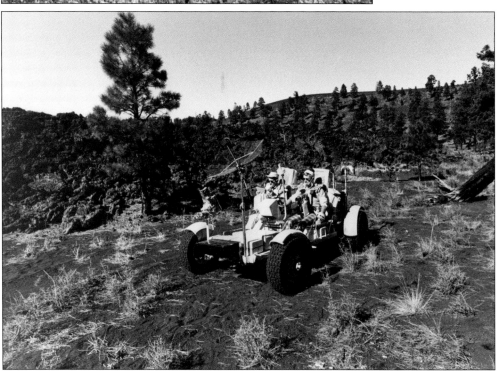

Geologist/astronaut Jack Schmitt (left) navigates while his Apollo 17 crewmate Gene Cernan drives *Grover* during a field exercise near the Cinder Lake Crater Field complex. While *Grover* was not an exact replica of the LRV that astronauts drove on the moon, it was close enough and made for effective simulations. (Courtesy of the Astrogeology Science Center, USGS.)

Thanks to his training with *Grover* in northern Arizona, Gene Cernan found driving the LRV on the moon fairly straightforward. Here, he passes in front of the Apollo 17 lunar module *Challenger* while exploring the moon's Taurus-Littrow region, so called for the nearby Taurus mountain range and Littrow Crater. (Courtesy of the Astrogeology Science Center, USGS.)

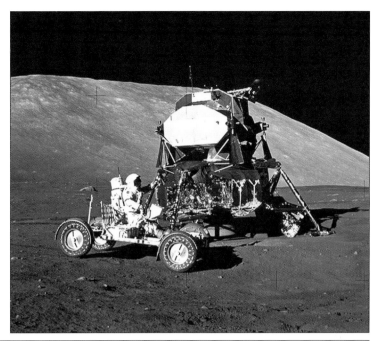

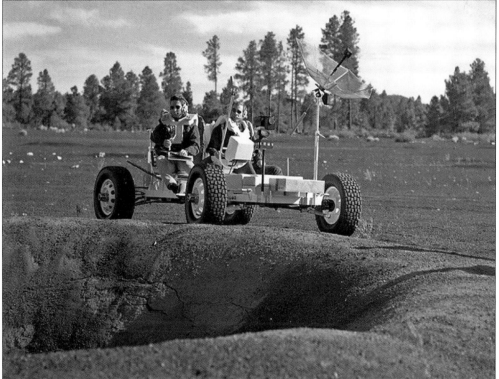

Apollo 15 astronauts Jim Irwin (left) and Dave Scott drive *Grover* near one of the man-made craters at Cinder Lake Crater Field 1. *Grover* has been preserved and is now on display in the Shoemaker Building at the US Geological Survey's Astrogeology Science Center in Flagstaff. (Courtesy of the Astrogeology Science Center, USGS.)

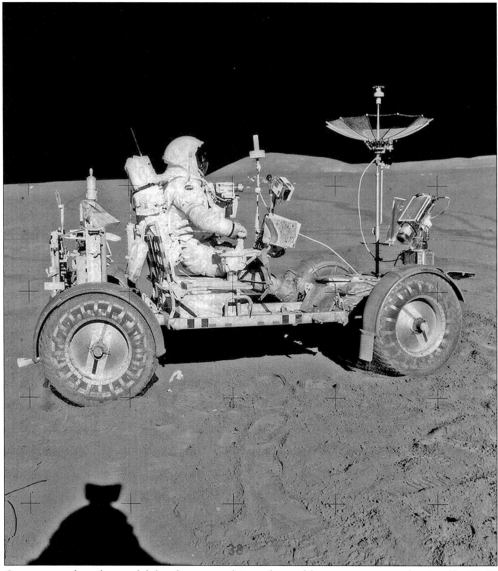

Grover served as the model for the rover ultimately used by astronauts on the Apollo 15–17 missions. Here, in a scene mimicking his training in the cinder fields around Flagstaff, Apollo 15 astronaut Dave Scott rides aboard the lunar rover at Hadley Rille on the moon. How important were the rovers to lunar exploration? During the Apollo 14 mission, Alan Shepard and Edgar Mitchell, without any sort of vehicle, were able to walk as far away as a half mile from their LEM (lunar module), and Shepard broke the record for distance traveled on the moon, at 1.1 miles. On Apollo 15, using a rover for the first time, Scott and Jim Irwin were able to explore well away from the LEM and traveled a stunning 17 miles. This allowed them to survey a much vaster area of the moon and also to easily transport equipment and rock samples around the lunar surface and back to the LEM. (Courtesy of NASA.)

During the first Apollo 17 moonwalk in 1972, astronauts Gene Cernan and Jack Schmitt had an unexpected problem with their rover—part of its right rear fender had fallen off, and without the fender, powdery moon dust sprayed up. Flagstaff scientists in mission control soon came up with the solution of using duct tape to mold several laminated geological maps together in the shape of the broken fender. (Courtesy of NASA.)

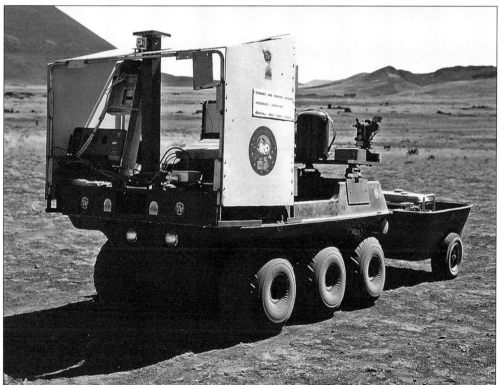

In 1970, NASA brought a modified Amphicat to northern Arizona to test a prototype navigational system proposed for later moon missions. The Amphicat was a six-wheeled, all-terrain vehicle built in the 1960s and 1970s by Mobility, Inc., of Michigan. It is shown here pulling a trailer in a March 1970 exercise at Merriam Crater. (Courtesy of the Astrogeology Science Center, USGS.)

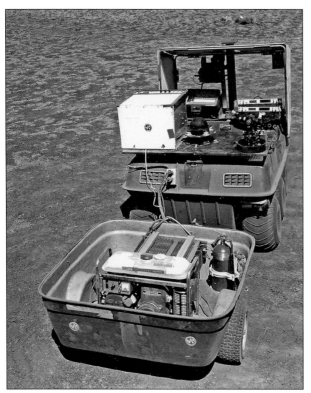

The Amphicat was never used on the moon, but many people might remember it as the type of vehicle driven by the four main characters in a television program that ran from 1968 to 1970, *The Banana Splits Adventure Hour*. In this show, the vehicles were called "Banana Buggies." (Courtesy of the Astrogeology Science Center, USGS.)

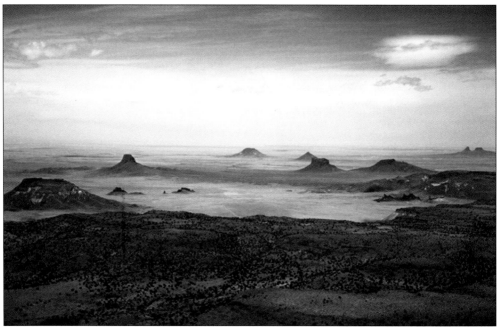

Hopi Buttes, located in eastern Arizona near Dilkon, is a volcanic field consisting of several hundred maars (shallow volcanic craters) and diatremes (volcanic pipes). Located mostly on the Navajo Reservation, it was a common site for testing various lunar vehicle prototypes and other equipment, as well as training astronauts. (Courtesy of the Astrogeology Science Center, USGS.)

While the LRVs proved to be the vehicle of choice for traveling on the moon, other options had been considered. One was developed by Bell Aerospace and called the Lunar Flying Vehicle (LFV), nicknamed the "Rocket Belt." Here, Gene Shoemaker tries on the device during a demonstration at Hopi Buttes. (Courtesy of the Astrogeology Science Center, USGS.)

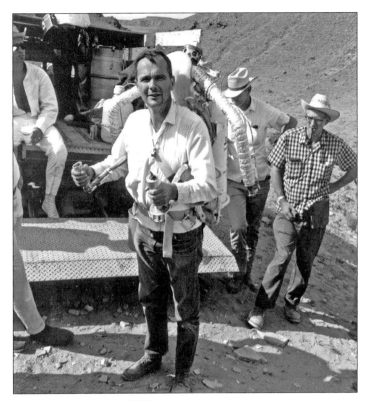

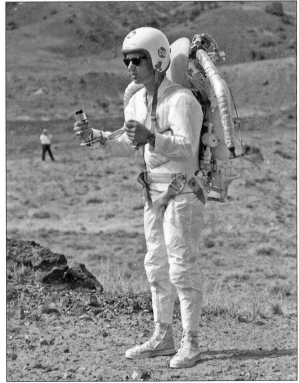

Here is a close-up of rocket belt pilot William Suitor modeling the LFV. It could carry a person up to about 30 feet in the air and travel up to 10 miles per hour, but it flew for only about 20 seconds. (Courtesy of the Astrogeology Science Center, USGS.)

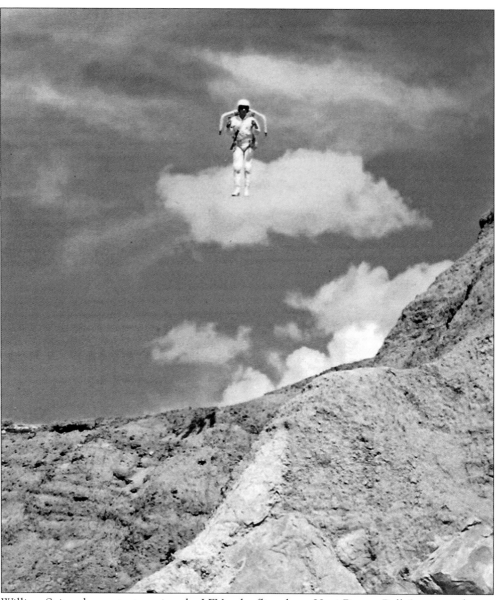

William Suitor demonstrates using the LFV as he flies above Hopi Buttes. Bell Aerospace began developing the rocket belt in the 1950s for the US Army. The system was famously demonstrated outside of the Pentagon, among other locations, but problems with fuel, stability, and maneuverability led to its cancellation as a military application. When it was tested as a lunar transportation option, officials came to the same conclusion about its difficulty of use. While the LFV was never used on the moon, it did become a hit in pop culture, in an example of art imitating real life. In the 1965 James Bond film *Thunderball*, the title character straps it on and escapes from the bad guys. The belt also appeared in the 1960s television show *Lost in Space*, when the character Don West used it to fly across an alien world. (Courtesy of the Astrogeology Science Center, USGS.)

Five

INSTRUMENT DEVELOPMENT

On a warm July evening in 2012, a retired engineer from Ohio spoke to a group of 700 guests who had descended upon Flagstaff, Arizona, to celebrate the commissioning of Lowell Observatory's new state-of-the-art tool for studying the stars, the Discovery Channel Telescope. The evening culminated years of designing, building, and sweating over a new instrument created for very specific research purposes.

"Almost a half century ago," said the engineer, "some astronomers designed an experiment . . . to compute the distance between Earth and the moon based on the time it would take for a beam of light to travel up to a mirror located on the surface of the moon and be reflected back to Earth. I wasn't one of the scientists on this project. I was a sort of a technician. My job in the experiment was to install the mirror. So, after about a three-and-a-half-day trip to the site I set about the job of unloading the mirror."

The experiment proved successful, though few people today are aware of it. Instead, they remember the expedition itself, as it was mankind's first visit to another world. The engineer's name was Neil Armstrong, and the instrument he deployed was one of dozens that he and his fellow astronauts took to the moon in the name of scientific exploration. Like the Discovery Channel Telescope, these instruments were designed for very specific conditions, in this case those of the moon.

At first glance, activities as pedestrian as collecting rocks or taking pictures of the landscape seem like they should be straightforward no matter the location. But throw in a fat, unwieldy pair of gloves that protect astronauts from the harsh lunar environment or the moon's reduced gravity compared to that of Earth and the need for specialized instrumentation to carry out this work on this moon is apparent. Thus, engineers in northern Arizona designed, built, and tested geology hammers, cameras, collecting scoops, tool carriers, and other devices necessary for lunar exploration.

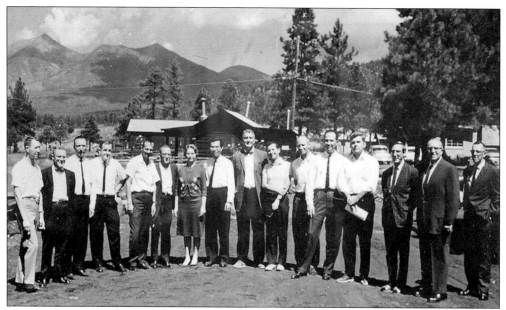

Gene Shoemaker brought the USGS Astrogeology Branch to Flagstaff in 1963. Until a permanent facility could be built on McMillan Mesa, the branch was housed at the Museum of Northern Arizona. The director of the museum was Ned Danson, father of television star Ted Danson. (Courtesy of the Astrogeology Science Center, USGS.)

In order to build and maintain the growing collection of field vehicles, geology instruments and tools, and related equipment, the USGS needed adequate space for machinists to work and so rented various facilities around Flagstaff. One site was this machine shop, located at 1733 North West Street on the east side of Flagstaff. (Courtesy of the Astrogeology Science Center, USGS.)

A critical piece of equipment for astronauts on the moon was a space suit, which protected them from the harsh conditions of space. Starting in 1964, the USGS tested several versions of suits, with geologists or other USGS personnel often wearing them. This image shows the first USGS test, carried out at Bonito Lava Flow near Sunset Crater. (Courtesy of the Astrogeology Science Center, USGS.)

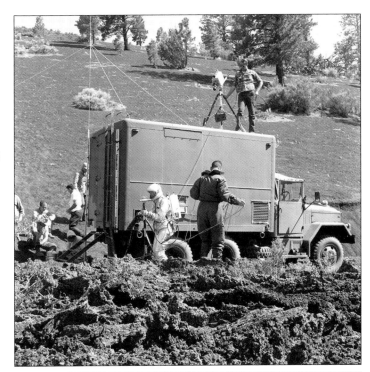

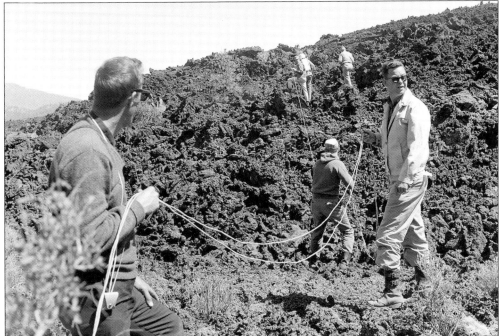

One of the many aspects of space suits that had to be tested was the ability of the wearer to communicate. Here, a USGS staff member wearing a space suit climbs over Bonito Lava Flow during the first space suit test in northern Arizona, in June 1964. Technicians trail behind, holding communication cables that connect to a truck-mounted command center. (Courtesy of the Astrogeology Science Center, USGS.)

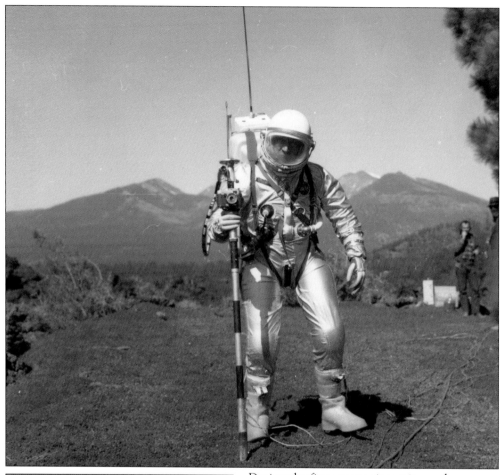

During the first space suit test in northern Arizona, a USGS staff member (probably Gene Phillippi) holds a prototype of the lunar staff, a device that could contain a variety of instruments, in this case a sun compass. The lunar staff was eventually scrapped and never used on the moon. (Courtesy of the Astrogeology Science Center, USGS.)

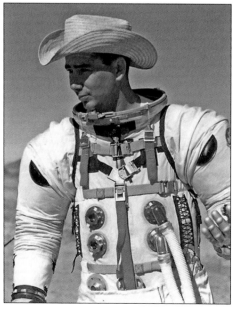

During a field test of an Apollo space suit in northern Arizona, USGS geologist Joe O'Connor swapped an astronaut helmet for a cowboy hat; he surely could be called a space cowboy. The space suits ultimately worn by astronauts on the moon were made by a division of the company that manufactured Playtex undergarments. (Courtesy of the Astrogeology Science Center, USGS.)

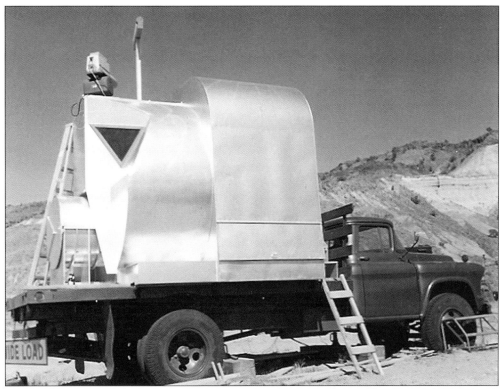

During their stays on the lunar surface, the astronauts operated out of lunar modules (LM). For training purposes, the USGS built several different models. They were mounted on trucks or stands so that the height of their viewing windows and access platforms matched those of the actual LMs on the moon. Here is one made of wood and sitting on the back of a truck during an October 1965 test at Hopi Buttes. (Courtesy of the Astrogeology Science Center, USGS.)

Here is a view looking out of the triangular window of the LM model. In the distance is Chezhin-Chotah Butte, part of the Hopi Buttes volcanic field located some 90 miles east of Flagstaff. Part of the training here involved crew members identifying nearby geological features, a skill necessary for astronauts for pinpointing their location when they landed on the lunar surface. (Courtesy of the Astrogeology Science Center, USGS.)

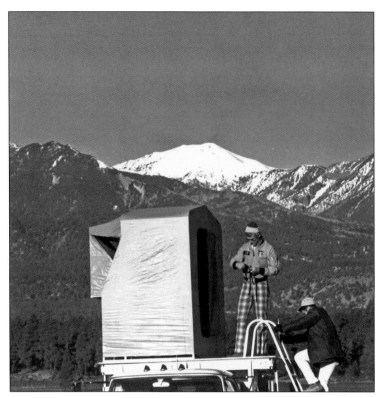

Here is a truck-mounted, canvas LM model that Gene Cernan (left) and Jack Schmitt climbed onto at the Cinder Lake Crater Field complex. This November 3, 1972, training session was the last for the crew before their Apollo 17 flight—four days later—to the moon. (Courtesy of the Astrogeology Science Center, USGS.)

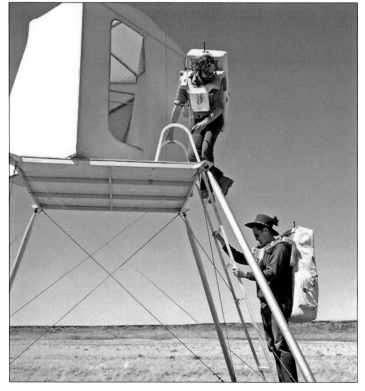

During a June 1971 training session at the Cinder Lake Crater Field complex, Apollo 16 astronauts John Young and Charlie Duke drove *Grover*, collected soil samples, and practiced climbing and making observations from yet another LM model. Here, Duke (bottom of ladder) climbs onto the LM with an unidentified technician. (Courtesy of the Astrogeology Science Center, USGS.)

As practiced at the cinder fields around northern Arizona, Alan Bean climbs down the LM ladder to the lunar surface during his Apollo 12 mission. Grumman Aircraft, which had built one of the prototype lunar roving vehicles (LRV) tested in Flagstaff, designed and built all of the LMs. (Courtesy of NASA.)

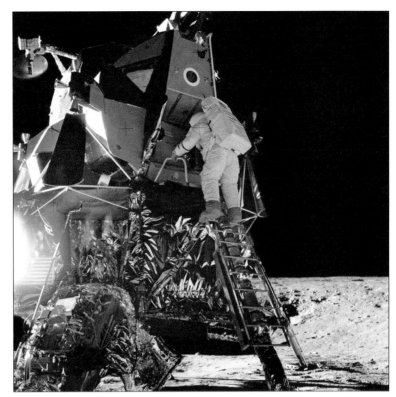

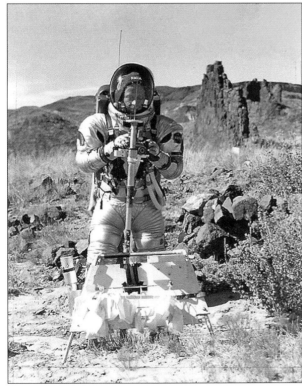

To help astronauts move tools and rock samples around the moon, engineers envisioned some sort of carrying device. Looking at early designs, geologist Joe O'Connor saw several flaws and, over drinks at Flagstaff's Monte Vista Hotel bar, he sketched out a better design on a napkin. Thus was born the tool carrier, shown here during a field test by geologist Gordon Swann. (Courtesy of the Astrogeology Science Center, USGS.)

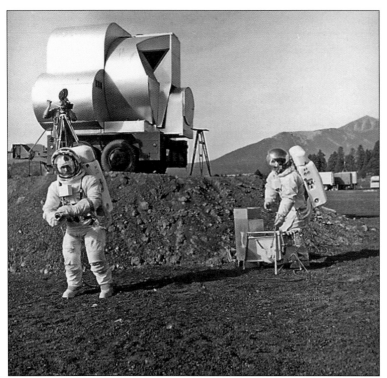

Technicians from the USGS would first test hardware typical of the various instruments and equipment that the astronauts used on the moon to judge its effectiveness and develop procedures for its use. Here, USGS staff use a mock-up of the tool carrier (they often called it the "lunar walker") during an exercise at the Cinder Lake Crater Field complex. (Courtesy of the Astrogeology Science Center, USGS.)

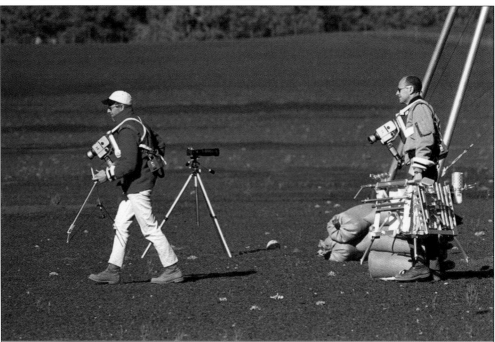

During this October 1969 training session at the Cinder Lake Crater Field complex, Alan Bean carries a tool carrier mock-up while Pete Conrad walks ahead of him. The carrier sat on a three-legged base that made it stable when sitting on the ground. (Courtesy of the Astrogeology Science Center, USGS.)

A month after training with the tool carrier in Flagstaff, Pete Conrad uses it on the moon while exploring the geology of the Oceanus Procellarum region. The cart's height allowed astronauts to easily access it without having to bend much. The tool carrier was used on the Apollo 12 and, in modified form, Apollo 14 missions. (Courtesy of NASA.)

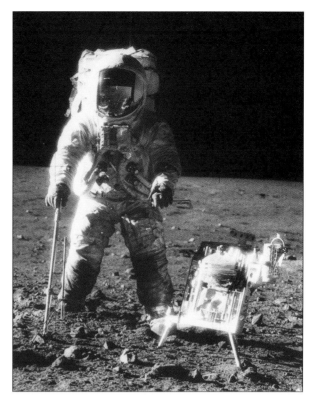

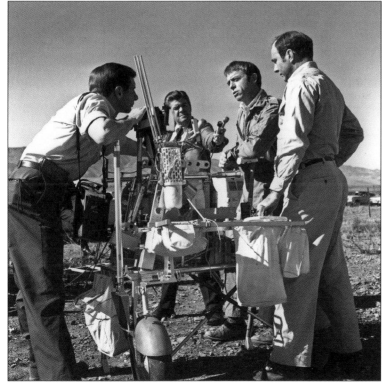

For the Apollo 14 mission, engineers built a wheeled version of the tool carrier. Crew members Alan Shepard (second from right) and Edgar Mitchell (right) trained with a mock-up of this device at the Black Canyon Crater Field in November 1970. They were joined by ABC science reporter Jules Bergman (left) and an unidentified ABC technician. (Courtesy of the Astrogeology Science Center, USGS.)

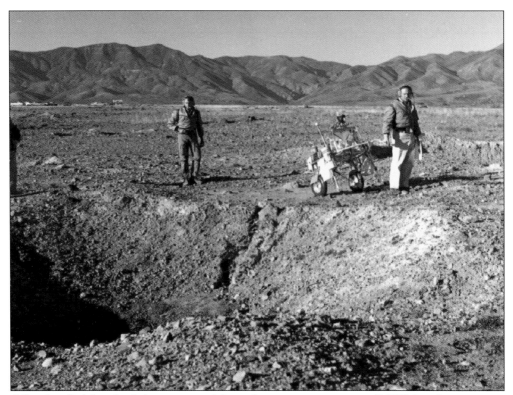

Officials called the wheeled carrier a modularized equipment transporter (MET), but the astronauts referred to it simply as the golf cart. The wheels allowed it to be pulled, rather than carried, across the lunar surface. Here, Edgar Mitchell tugs the MET, while Alan Shepard looks on during training at the Black Canyon Crater Field. (Courtesy of the Astrogeology Science Center.)

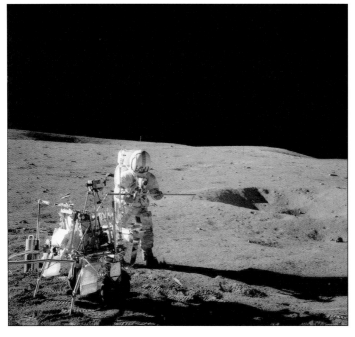

On the moon, Alan Shepard and Edgar Mitchell struggled with the MET as it was difficult to pull through rough terrain. At one point, they gave up pulling and carried the MET until they tired. Apollo 14 was the only mission that used the MET; all later mission used rovers that carried both the astronauts and their cargo of equipment and rock samples. (Courtesy of NASA.)

One of the most fundamental tools for geology fieldwork anywhere, including the moon, is a geology hammer. On the first two manned lunar missions, astronauts used relatively light versions for forcing core tubes into the soil. Later missions involved more in-depth geological exploration so astronauts used heavier and sturdier hammers, like the one illustrated here. (Courtesy of the Astrogeology Science Center, USGS.)

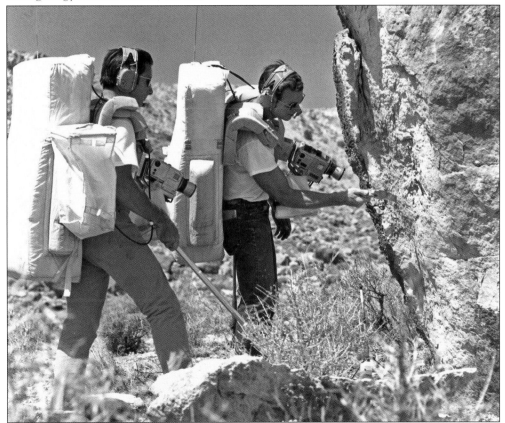

Apollo 15 was the first mission to do extended geological fieldwork. Comdr. Dave Scott enthusiastically took on the challenge of learning geology, and this resulted in a very successful mission. Here, in a June 1971 training session at Coconino Point (near Cameron, Arizona), Scott uses the heavy geology hammer to chip some rock. His crewmate Jim Irwin looks on. (Courtesy of the Astrogeology Science Center, USGS.)

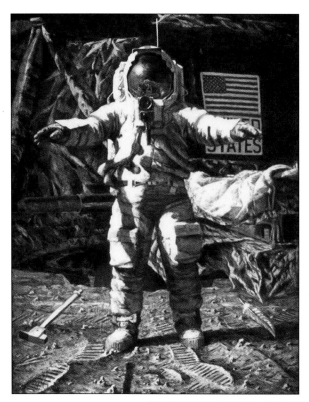

While on the moon, Dave Scott used a geology hammer not only to collect rocks but also to prove the theory stated by Galileo Galilei centuries ago that two objects, no matter their mass, will fall at the same rate in a vacuum. Astronaut/painter Alan Bean depicted Scott's demonstration in his 1986 painting *The Hammer and the Feather*, shown here. (Courtesy of Alan Bean.)

While on the moon and wearing their bulky space suits, astronauts had difficulty bending over, so engineers designed tools that limited their need to do so. For plucking rocks off of the lunar surface, they used tongs, like these held by an unidentified technician during a field test in Arizona. (Courtesy of the Astrogeology Science Center, USGS.)

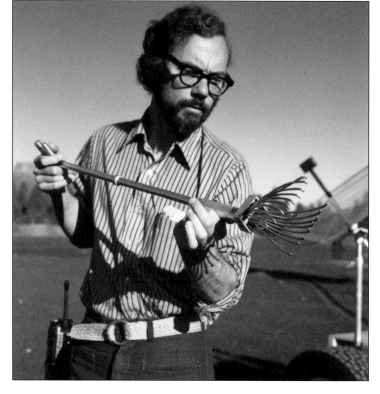

As with many of the moon instruments and tools, different missions often used different versions of tongs. In this photograph, Apollo 12 astronaut Pete Conrad prepares to collect a rock with the tongs measuring about 26 inches long. This device could pick up rocks up to about 2.5 inches across. Later missions used a modified version that allowed for the collection of larger rocks. (Courtesy of NASA.)

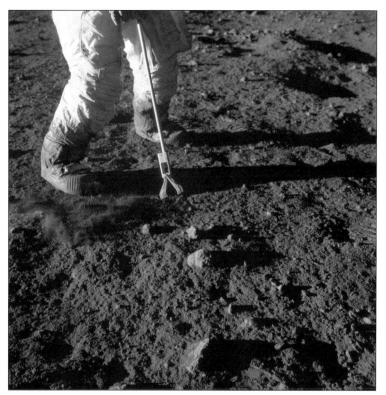

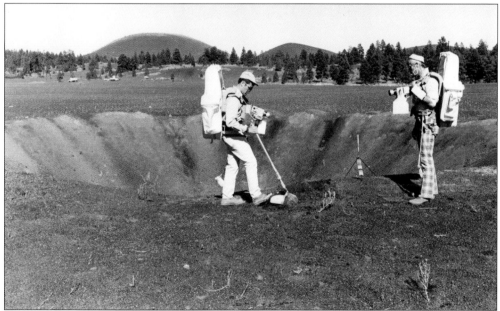

This glorified rake was another important geology tool for the astronauts on the moon. It allowed them to collect small rock samples more efficiently than by individually plucking them with the tongs. In this training session at the Cinder Lake Crater Field complex, Jack Schmitt (left) practices using the lunar rake while Gene Cernan photographs the procedure. (Courtesy of the Astrogeology Science Center, USGS.)

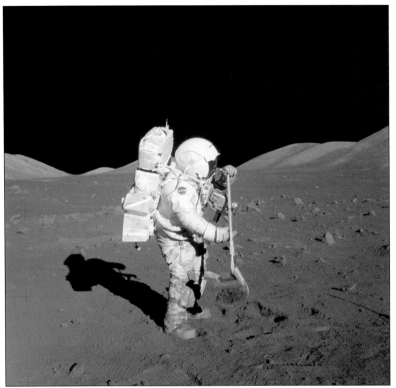

Jack Schmitt, the only geologist to walk on the moon, practices his craft with the lunar rake. After dragging the stainless-steel-tined instrument through the regolith, Schmitt shook out the loose soil until he was left with a collection of small rocks. Schmitt's shoes and the lower section of his space suit have been darkened by a coating of the fine lunar soil that he kicked up. (Courtesy of NASA.)

For collecting soil samples on the moon, astronauts used a long-handled scoop that allowed them to gather the sample and then dump it into collecting bags. At the Cinder Lake Crater Field complex in June 1971, Apollo 16 astronaut Charlie Duke (right) stands in front of *Grover* as he practices the procedure with an unidentified technician. (Courtesy of the Astrogeology Science Center, USGS.)

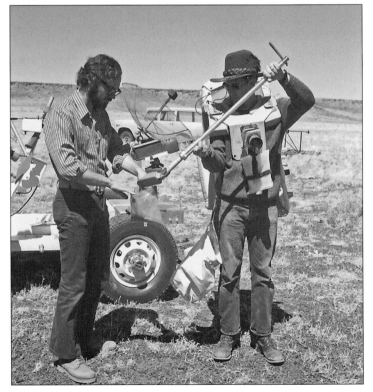

Astronauts collected soil core samples using a hand-driven borer. Geologist Tim Hait, dressed in the space suit and standing beside the tool carrier, practices the technique in a March 1968 field session at Cinder Lake Crater Field 1. (Courtesy of the Astrogeology Science Center, USGS.)

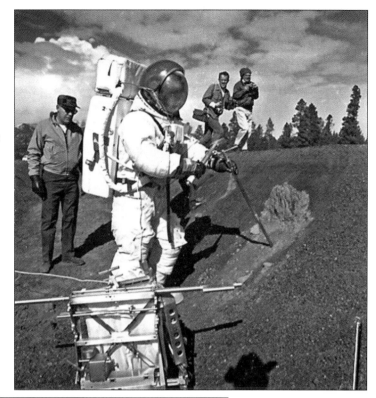

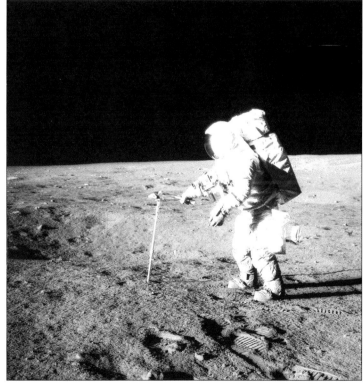

Apollo 12 astronaut Alan Bean uses a lighter-weight geology hammer to drive the core sample borer into the regolith. While astronauts left most of their geology tools and instruments on the moon when they left, Bean brought back his hammer and for years has used it in creating his unique paintings of the moon. (Courtesy of NASA.)

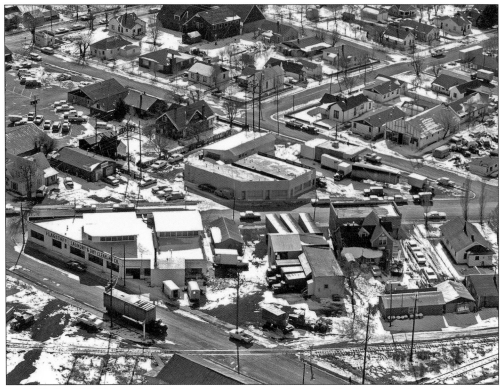

In 1965, the USGS leased a building (in the center of this 1965 photograph) at 16–18 Mike's Pike Street in Flagstaff. The facility, which was soon nicknamed the "rock lab," was used as a geology laboratory, where scientists could prepare rocks and make thin sections for petrological and mineralogical studies, all in support of various lunar research and astronaut training efforts. (Courtesy of the Astrogeology Science Center, USGS.)

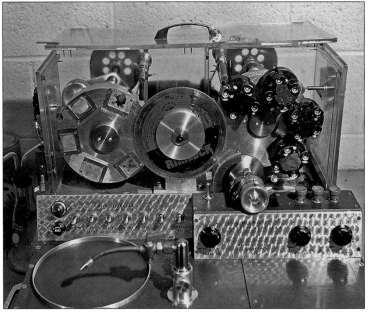

This is one of many machines used in the rock lab. It was designed to both cut rocks and make thin sections of the samples. Scientists then viewed these slides under a petrographic microscope to identify the mineralogical composition of the rock, information critical to determining its origin and evolution. (Courtesy of the Astrogeology Science Center, USGS.)

Gene Shoemaker envisioned several components that would be used on the lunar staff, including the Apollo Lunar Geological Exploration Camera (LGEC). This image shows an early model of this stereometric camera. The photographer would use the middle hole for lining up the camera, while stereo pictures were captured through the other two holes. (Courtesy of the Astrogeology Science Center, USGS.)

Here is a prototype of the LGEC, which was designed to take stereo images of lunar features. Machinist W.E. Fahey built it in a USGS machine shop in Flagstaff. While USGS staff thoroughly tested this camera, it was ultimately never used on the moon. (Courtesy of the Astrogeology Science Center, USGS.)

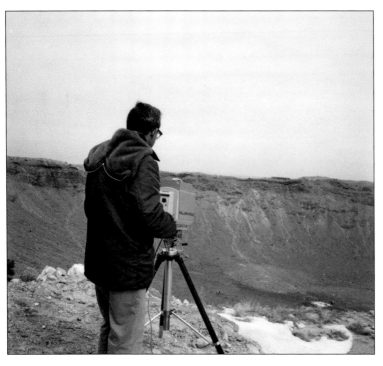

John M'Gonigle was a member of the film documentation unit at the USGS. This group kept busy recording the wide variety of instrument testing, astronaut training, crater simulation, and other moon-related efforts. Here, M'Gonigle stands near a patch of snow at the rim of Meteor Crater as he uses the camera for an image resolution test. (Courtesy of the Astrogeology Science Center, USGS.)

USGS staff designed a gnomon for calibrating lunar pictures taken by the astronauts. The vertical, central shaft featured a gray scale for calibrating black and white images, while one of the supporting tripod legs held a color chart for calibrating color images. Here, astronaut Alan Shepard practices deploying the device during a field test at the Black Canyon Crater Field near Cottonwood. (Courtesy of the Astrogeology Science Center, USGS.)

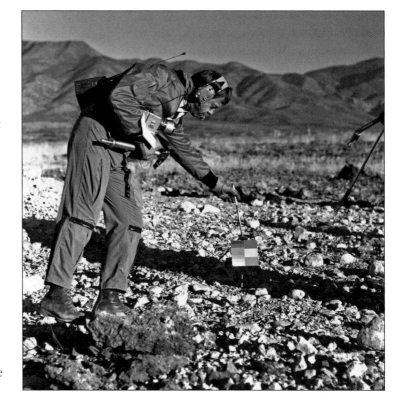

Apollo 16 astronaut John Young stands behind a gnomon he had deployed on the lunar surface. This device was simple yet quite effective, allowing scientists back on Earth to create accurate contour maps and stereo pairs of images that allowed them to perceive depth of the photographed features. (Courtesy of NASA.)

NASA wanted to document the astronaut's historic lunar expeditions, from terrestrial training to the actual moon landings. This meant developing appropriate cameras and techniques for filming and photographing the activities. At Meteor Crater in February 1966, John M'Gonigle of the USGS tests a television camera. (Courtesy of the Astrogeology Science Center, USGS.)

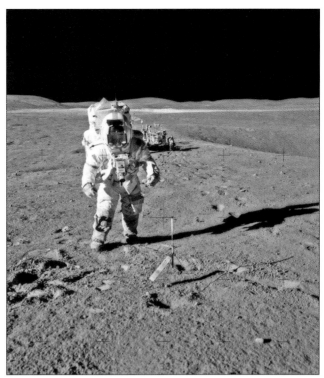

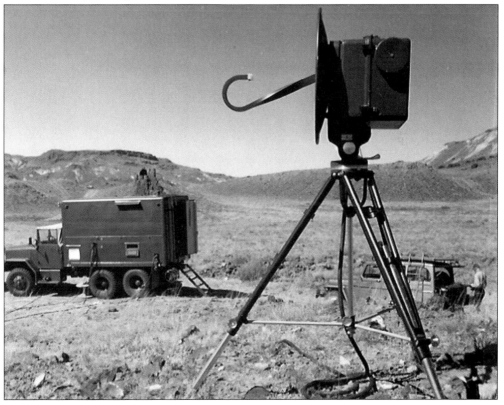

In the center of this 1968 photograph is the Arizona Bank building in downtown Flagstaff. The USGS rented space here for staff offices and data processing areas. For example, during field simulations at the Cinder Lake Crater Field complex and elsewhere, personnel radioed observations to a control center housed in this building, where scientists could then practice analyzing and processing the information. (Courtesy of the Astrogeology Science Center, USGS.)

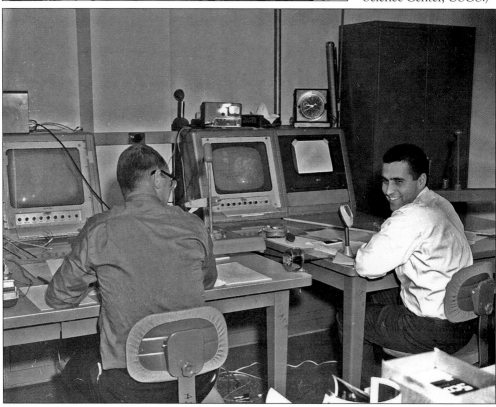

On the fifth floor of the Arizona Bank building in Flagstaff, geologist Bob Sutton (left) and Apollo 17 astronaut Jack Schmitt (right) work in the Command, Reception, and Analysis (CDRA) facility, where staff practiced receiving and evaluating data from geology and communications tests around northern Arizona. (Courtesy of the Astrogeology Science Center, USGS.)

In 1967, the USGS expanded the CDRA program and moved it to a new building at 2717 North Fourth Street, next to another, much larger new structure at 2720 North Fourth Street, which housed several other USGS programs. This c. 1969 photograph shows, from left to right, geologists Al Chidester, Ivo Lucchitta, and John M'Gonigle working in what became known as the Apollo Data Facility (ADF). (Courtesy of the Astrogeology Science Center, USGS.)

Geologist George Ulrich reviews maps and monitors in the ADF. The work of Ulrich and his colleagues showed NASA the value of including a science operations room at mission control during the Apollo missions, a place where scientists could quickly receive and analyze incoming geological data from the astronauts and then share it with mission control. (Courtesy of the Astrogeology Science Center, USGS.)

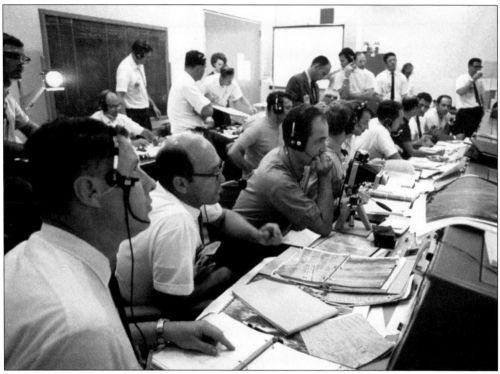

Gene Shoemaker (right) and his lunar geology experiment team stand in the science operations room of mission control—at Houston's Manned Spaceflight Center—during the Apollo 11 mission. The group played a key role in helping ensure the astronauts met their scientific objectives on this and later flights. (Courtesy of the Astrogeology Science Center, USGS.)

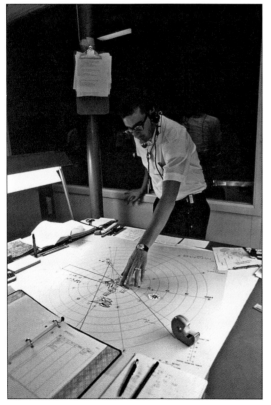

Geologist Gerald Schaber was part of the lunar geology experiment team for several Apollo flights to the moon, including the historic first one that saw Neil Armstrong and Buzz Aldrin walk on the lunar surface. Schaber was in charge of tracking the precise location of the astronauts while they moved about the moon and recording their traverses on maps. (Courtesy of the Astrogeology Science Center, USGS.)

Six

MAPPING THE MOON

In the late 1950s, while still at the University of Chicago's Yerkes Observatory, Gerard Kuiper realized that existing moon maps were woefully out of date. Accordingly, Kuiper, in association with British expats Ewen Whitaker and Dai Arthur, began work on a new photographic atlas of the moon.

In 1960, the team moved to the Lunar and Planetary Laboratory (LPL) in Tucson, where efforts began toward the creation of a "rectified" lunar atlas. By projecting Earth-based photographs of the moon onto a large plaster sphere, the structure of features near the limbs of the moon not seen clearly from Earth could be better appreciated. In this way, Kuiper and his graduate student William Hartmann recognized the significance of multi-ring basins, like Mare Orientale, which have proven to be the basic unit of lunar topography.

Meanwhile, at the USGS in Flagstaff, Gene Shoemaker, Robert Hackman, Richard Eggleton, and others were producing the first geologic maps of the moon—maps showing stratigraphic relationships among various lunar surface units.

Another lunar mapping project, organized by the Aeronautical Chart and Information Center (ACIC), a branch of the US Air Force, used lunar photographs as a base with the addition of fine detail noted by visual observers. The ACIC lunar mapping project was housed at Lowell Observatory, and the observers used Lowell telescopes, including the famed 24-inch Clark refractor. The resulting maps show the moon as it appears in a large telescope, under excellent seeing conditions.

Mapping also took place from lunar orbit. A series of automatic probes, notably the five Lunar Orbiters that went into lunar orbit between August 1966 and August 1967, imaged the moon in great detail, including the far side. In all, only a small area near the south pole was not covered. Some of the frames were spectacular indeed: *Lunar Orbiter 1*'s view of Earth rising above the lunar wastelands, for example, anticipated the famous earthrise image from *Apollo 8* in December 1968. The cosmic perspective was expanding.

Gerard Kuiper (left) and Ewen Whitaker stand at the controls of the University of Arizona's 61-inch telescope on Mount Bigelow in Tucson's Catalina Mountains. In 1955, Whitaker attended a talk by Kuiper in Dublin, in which he sought to stimulate interest in mapping the moon. Whitaker sent Kuiper a letter afterwards, and Kuiper hired him at once to join him at Yerkes Observatory. (Courtesy of Ewen Whitaker.)

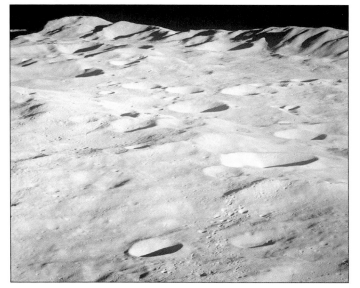

In 1951, Ewen Whitaker, as an astronomer at the Greenwich Royal Observatory, became hooked on observing the south polar region of the moon, which was only visible under a highly foreshortened view. He recalled that the appearance of its mountainous terrains, such as shown here, resembled what would be seen through a spaceship porthole. (Courtesy of Leo Aerts.)

The *Photographic Lunar Atlas*, for which much of the work was done by Ewen Whitaker and Dai Arthur, then working in the northeast tower of the Yerkes Observatory building in Williams Bay, Wisconsin, was funded by the National Science Foundation and the US Air Force Cambridge Research Laboratories. A typical field is shown here, part of Mare Tranquillitatis, including the future Apollo 11 landing site. (Courtesy of Ewen Whitaker.)

At the LPL in Tucson, Gerard Kuiper and his colleagues projected photographs of the moon onto this three-foot-diameter, white half-globe, then rephotographed the globe from different angles, capturing images of limb regions as they would look overhead. These so-called rectified photographs helped clarify the true structure of lunar features near the limbs. (Courtesy of William Sheehan.)

In this photograph taken about 1960, William Hartmann, one of several gifted graduate students to join Gerard Kuiper at the LPL at the University of Arizona, is shown taking the rectified photographs of the moon in the Quonset hut, which served as the LPL's first quarters on the University of Arizona campus. (Courtesy of the Lunar and Planetary Laboratory.)

This is an image from the *Rectified Lunar Atlas* (1963), showing Mare Imbrium as if from overhead. Rectified images such as this first showed that the highly foreshortened Mare Orientale (Eastern Sea) is a multi-ring basin, and that multi-ring basins are large impact features and the controlling large-scale unit of lunar geology. (Courtesy of Ewen Whitaker.)

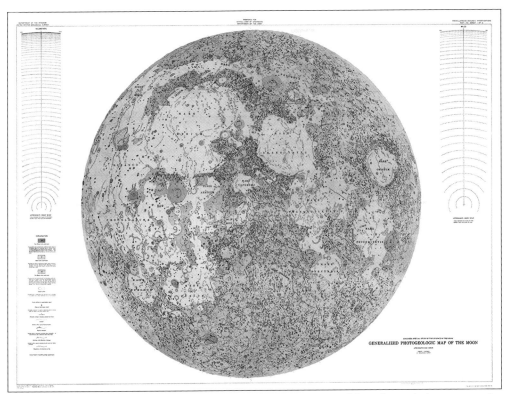

This is the first map to portray lunar stratigraphic units, one of four sheets belonging to the "Engineer Special Study" prepared in 1959 and 1960 by Robert Hackman and Arnold Mason of the USGS. This pioneering map showed only three stratigraphic units—premare, mare, and postmare. Soon afterward, Shoemaker used it as a base for a geologic map of the Copernicus region. (Courtesy of the Astrogeology Science Center, USGS.)

Gene Shoemaker's prototype geologic map of Copernicus (1960) shows inferred stratigraphic units associated with landmark features. The Copernicus impact, which occurred 810 million years ago based on dating of material from a ray sampled during the Apollo 14 mission, established what became known as the most recent, or "Copernican" stratigraphic era in lunar geologic history. (Courtesy of the Astrogeology Science Center, USGS.)

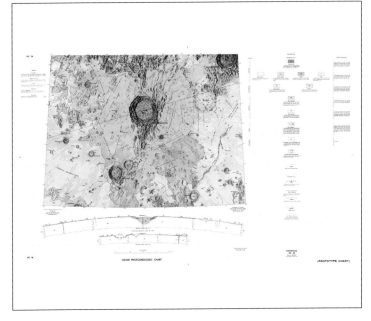

During his latter years working at the University of Chicago's Yerkes Observatory, Gerard Kuiper, shown here, realized that the best photography of the time was not good enough to capture fine details of the lunar surface. He suggested that visual observing through a telescope, which was more effective at capturing details, would help overcome this problem and allow cartographers to make the best possible maps. (Courtesy of Lowell Observatory.)

In the late 1950s/early 1960s, the Aeronautical Chart and Information Center (ACIC), based in St. Louis, was creating lunar charts in support of NASA's manned space program. Following Kuiper's advice, ACIC staff members traveled to Yerkes Observatory to observe the moon through the historic 40-inch refractor, shown here during Albert Einstein's well-documented 1921 visit. (Courtesy of Yerkes Observatory.)

The weather at Yerkes proved too cloudy for regular lunar observations, so ACIC director Bill Cannell, in hopes of finding a better observing location, visited the US Naval Observatory's station in Flagstaff, Arizona, and observed the moon through its now historic 40-inch Ritchey Telescope. The observing conditions in Flagstaff were excellent, and Cannell realized Flagstaff would be an ideal location for regular lunar observing. (Courtesy of Lowell Observatory.)

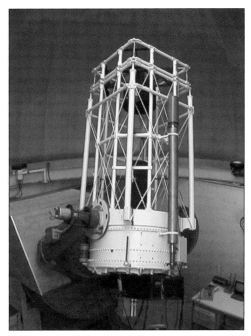

The US Naval Observatory's 40-inch telescope was in regular use for research and so was not available for the moon mapping effort. However, director Art Hoag suggested to Cannell that he talk with Lowell Observatory director John Hall to see if he could help. This 1980 photograph shows Hoag (third from right) and Hall (right), along with historian William Graves Hoyt (second from right) and their wives. (Courtesy of Lowell Observatory.)

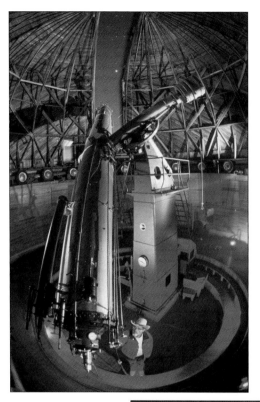

As luck would have it, Hall did have an available telescope at Lowell, the venerable 24-inch Clark refractor, shown here. After some initial testing, Cannell found it to be ideal for the task and began the ACIC moon mapping program at Lowell Observatory that ran from 1961 through 1969. (Courtesy of Lowell Observatory.)

Initial ACIC staff members at Lowell include Cannell, who would direct the efforts; telescope observer James Greenacre; and illustrator Patricia Bridges. They established a small ACIC office in a building that once served as the observatory's machine shop. Shown here are Bridges, flanked by Lowell astronomer E.C. Slipher (left) and Cannell. (Courtesy of Lowell Observatory.)

When the moon was up in the sky, Cannell and Greenacre spent much of their time at the Clark Telescope, observing and sketching lunar details. They then shared this information with Patricia Bridges, shown here, who used them and photographs of the moon as a guide as she airbrushed details into what eventually evolved into full-fledged maps. (Courtesy of Patricia Bridges.)

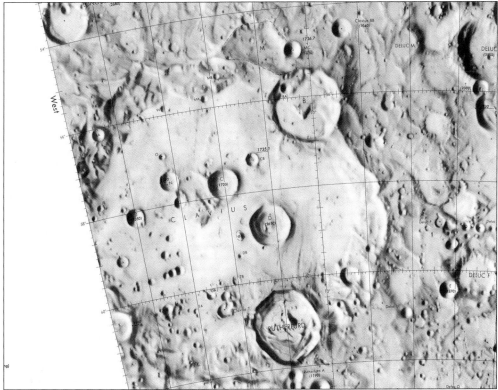

The ACIC efforts at Lowell were supplemented by those of other ACIC observers around the world. The final result was the production of beautifully detailed maps that were as much art as science. This one shows a segment of chart identified as "Clavius, LAC 126," centered around the spectacular crater Clavius, the third-largest crater on the near side of the moon. (Courtesy of Lowell Observatory.)

Once Patricia Bridges finished creating a map, Cannell or Greenacre would drive it down to the Lunar and Planetary Laboratory in Tucson. The team of moon experts there, including Kuiper, Whitaker (shown here), and Arthur, closely examined the map for accuracy and offered suggestions for improvement. This was a critical step in ensuring that the final product was of the highest possible quality. (Courtesy of Lowell Observatory.)

According to the January 16, 1963, edition of the *Arizona Daily Sun*, in early 1963, while Lowell's ACIC team furiously produced lunar maps, the era of astronaut training in northern Arizona arrived when the second class of astronauts—the "Next Nine"—came to Flagstaff for daytime geology training at Meteor Crater and Sunset Crater. (Courtesy of Northern Arizona University, Cline Library.)

In the evening, the astronauts drove to Lowell Observatory for dinner at director John Hall's house, followed by a briefing in the ACIC office by Cannell and his staff about their moon-mapping efforts. In this picture, Patricia Bridges shows Pete Conrad how she uses an airbrush to depict the moon's surface details. (Courtesy of Lowell Observatory.)

This visit to the ACIC office was important for building the astronauts' understanding of how to recognize lunar features, from both photographs and maps. This skill would be critical on the moon missions as they tried to pinpoint their location based on the appearance of nearby craters, mountains, and other features. Here, Jim McDivitt examines a photograph of the moon. (Courtesy of Lowell Observatory.)

Ed White (left) looks through a pair of stereo glasses as Frank Borman looks on. This brief training session in Flagstaff was a sort of homecoming for Borman, who grew up in Tucson, just four hours south of Flagstaff. Five years after his visit to Lowell, he would command the first manned mission to circle the moon, Apollo 8. (Courtesy of Lowell Observatory.)

John Young examines lunar photographs during the briefing at Lowell. Later in the evening, Young and his fellow astronauts broke into three groups, with one heading to the US Naval Observatory, the second to the observatory at Arizona State College (today called Northern Arizona University), and the third staying at Lowell. For several hours and into the next morning, they observed the moon through telescopes. (Courtesy of Lowell Observatory.)

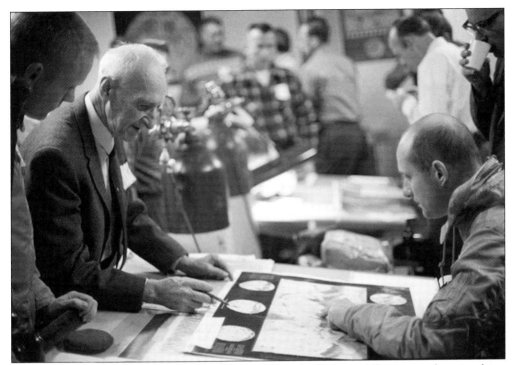

Lowell astronomer E.C. Slipher (second from left) had a long, prolific career photographing and studying the planets. While he did little moon research, the observing and photographic techniques he developed were quite applicable to lunar studies. Here, he reviews a Mars map with Neil Armstrong (left) and Tom Stafford (right). (Courtesy of Lowell Observatory.)

By the time the astronauts visited Lowell in 1963, the ACIC program was at full capacity with just the Clark Telescope. An additional telescope would allow for multiple observers to simultaneously see the moon, resulting in a faster rate of map production. With this in mind, Lowell Observatory acquired this 20-inch refracting telescope from amateur astronomer Ben Morgan of Texas. (Courtesy of Lowell Observatory.)

By 1965, the ACIC staff grew to more than a dozen. Shown here in front of the recently enlarged office are, from left to right, William Cannell, Sharon Gregory, Leonard Martin, Louise Riley, Fred Dungan, Barbara Vigil, Bob Maulfair, Tom Dungan, Cliff Snyder, James Greenacre, Gail Gibbons, Terry McCann, Bruce Faure, Pat Bridges, and Jim Jennings. (Courtesy of Lowell Observatory.)

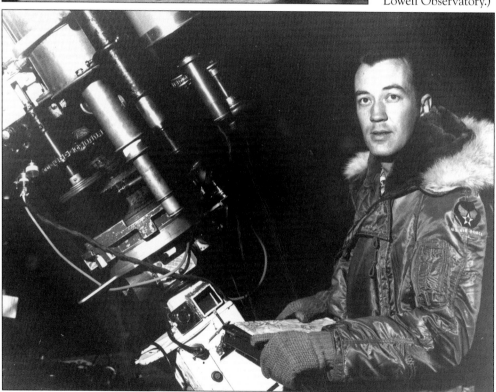

During the early years of the moon-mapping efforts at Lowell, photographic processing was carried out by a part-time technician. With the expansion of the program in the mid-1960s, photographic needs escalated so the ACIC hired Robert Maulfair as the full-time photographer He is shown here standing next to the 24-inch Clark Telescope. (Courtesy of Robert Maulfair.)

James Greenacre (left) and Edward Barr stand by the Clark Telescope, which is shown here with a 70-millimeter Hulcher camera attached. On October 29, 1963, they were studying the moon through the Clark Telescope and noticed bright colorings on the lunar surface, apparent evidence of some sort of activity. Other observers have seen similar transient lunar phenomena, but their true identity remains a mystery. (Courtesy of Lowell Observatory.)

Patricia Bridges left the ACIC office in 1965 and was succeeded as the prime illustrator by Jay Inge. For several years, he led a team in creating a globe of the moon for NASA, a process that involved depicting lunar features on strips ("gores"), which were ultimately assembled to form the globe. Show here are, from left to right, Paul Rodriguez, unidentified, Terrence McCann, and Inge. (Courtesy of Lowell Observatory.)

Here is the finished lunar globe, representing 99 percent of the lunar surface. With the completion of this globe in 1969, the ACIC office at Lowell closed. While some of the staff stayed at Lowell to work on other projects, many left. Jay Inge transitioned to the USGS office across town, and Patricia Bridges, after spending several years raising her kids, also went there. (Courtesy of Lowell Observatory.)

Moon mapping in Flagstaff thrived not only at Lowell Observatory's ACIC office but also at the USGS. In 1964, the USGS acquired a 30-inch reflecting telescope in support of this mapping effort and erected it 12 miles southeast of town, on the top of a volcanic spread of land called Anderson Mesa. (Courtesy of the Astrogeology Science Center, USGS.)

Geologist Elliot Morris, shown here at the 30-inch telescope, operated the telescope in its early years. The facility was located near Lowell Observatory's Perkins Telescope, and in 1972, when the USGS had ended the moon observing project, control of the telescope was transferred to Lowell Observatory. It later became the main telescope for a consortium of institutions, known as the National Undergraduate Research Observatories. (Courtesy of the Astrogeology Science Center, USGS.)

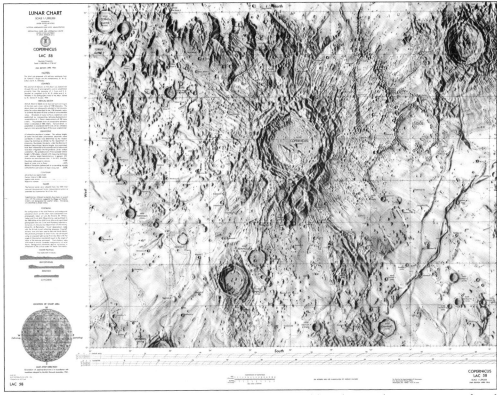

The section of this ACIC map shows Copernicus. This map, like others in the series, was produced by the merging of several technologies—the base was established with photographs of the moon, then fine details were added by visual telescopic observations, with the final product involving expert airbrushing. (Courtesy of the Astrogeology Science Center, USGS.)

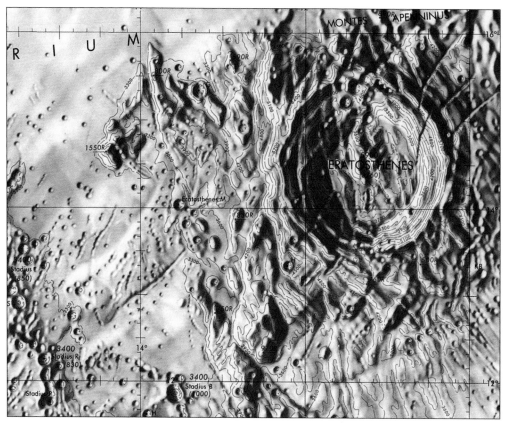

Here is a detail of the previous map. This focuses on the crater Eratosthenes, older than Copernicus and the namesake of the so-called Eratosthenian era in the geological record of the moon. The small craters in the lower left of this image are satellite craters created during the impact that formed Copernicus, a somewhat younger crater than Eratosthenes. (Courtesy of the Astrogeology Science Center, USGS.)

This modern CCD (charge-coupled device) image, taken by the skillful Belgian amateur astronomer Leo Aerts with a 14-inch Schmidt-Cassegrain telescope, is at roughly the same scale as the previous ACIC map image and invites comparison as to the level of detail and accuracy achieved by the ACIC mappers. (Courtesy of Leo Aerts.)

Here is a Lunar Orbiter used for ground tests on Earth. Five of these automated probes went into lunar orbit between 1966 and 1967 and imaged the moon in great detail, including the far side. The only area not imaged was around the south pole, which for a long time remained known as Luna Incognita and continued to be mapped by interested amateurs from Earth. (Courtesy of National Air and Space Museum.)

Anticipating the famous earthrise image taken by the astronauts of Apollo 8, *Lunar Orbiter 1* captured the first view of Earth rising above the moon on August 23, 1966. The image was long compromised by the quality of the scanning television system used at the time but has now been reprocessed and digitized as part of the Lunar Orbiter Image Recovery Project. (Courtesy of NASA/LOIRP/USGS.)

Here is the "picture of the century," showing Copernicus, shot by *Lunar Orbiter 2* on November 23, 1966, from a point 28 miles above the surface and 150 miles south of the crater. The southern rim and ejecta blanket are in the foreground, while the floor, central mountains, and slumped wall appear toward the top. This image was reprocessed and digitized as part of the Lunar Orbiter Image Recovery Project. (Courtesy of NASA/LOIRP/USGS.)

Another classic Lunar Orbiter frame is shown here. This one, taken by *Lunar Orbiter 4* on May 25, 1967, shows the multi-ringed Orientale impact basin. It measures 580 miles across its outer ring, known as the Cordilleras. The Eastern Sea is visible only under extreme librations from Earth; though its structure was first appreciated in the rectified lunar atlas images, its full grandeur awaited Lunar Orbiter images. (Courtesy of NASA/USGS.)

Seven

ON THE MOON

Despite early opposition from some in NASA headquarters, the geological exploration of the moon finally came into its own and gathered momentum with each succeeding Apollo mission. Each destination was debated and carefully selected from among alternatives. The six landing sites actually explored were far from enough, but within their limits, they succeeded in thoroughly revising people's understanding of the ancient satellite.

Apollo 11 in July 1969, had it done nothing else, would be assured a place in history had it simply landed and returned safely to Earth. It did more, though, as astronauts Neil Armstrong and Buzz Aldrin also returned the first rock samples from the moon. The Apollo 12 mission, which made a pinpoint landing in the Ocean of Storms near the automatic *Surveyor 3* spacecraft, brought back samples of pulverized material generally thought to belong to a ray from the comparatively fresh crater Copernicus. Apollo 13 was a near disaster and did not land on the moon. In the Apollo 14 mission, Alan Shepard and Edgar Mitchell reached the scientifically interesting Fra Mauro formation but fell short of their goals; becoming disoriented on the moon, the astronauts failed to reach their objective, Cone Crater, despite getting within 56 feet of its rim.

There then followed three missions that, from a geologic point of view, were epic. Apollo 15, led by geology enthusiast Dave Scott and copiloted by Jim Irwin, set down near Hadley Rille, fronting the towering lunar Apennines, the latter part of the ejecta thrown out when an asteroid formed the Imbrium basin some 3.8 billion years ago. It was the first mission to deploy a rover similar to that tested in Flagstaff. Apollo 16, sent to the crater Descartes, and Apollo 17, sent to the Taurus-Littrow Valley, were also highly productive—the latter was notable for the presence of Jack Schmitt, the only professional geologist to walk on the moon.

Since Apollo 17's return to Earth in December 1972, no one has returned. The moon has once more become a distant lamp in the night. Yet it is only 1.3 light-seconds in distance from Earth. People's exploration of the cosmos has truly only just begun.

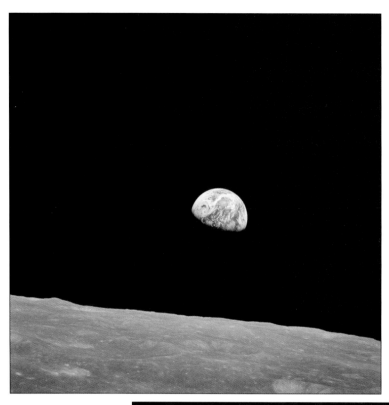

Apollo 8 astronauts Frank Borman, Jim Lovell, and Bill Anders all participated in the geology training for the moon landings but never got closer than 69 miles to the surface while making 10 lunar orbits in December 1968. Borman and Anders then retired, while Lovell was commander of the abortive Apollo 13 mission. Though none was a moonwalker, they did see this evocative earthrise. (Courtesy of NASA.)

This image shows *Apollo 11*'s approach to Apollo landing site 2 in the southwestern Sea of Tranquility. Site 2, into which the LM would make a nail-biting descent, is located just right of center at the edge of the darkness. The crater Maskelyne is at the lower right; Hypatia Rille is at the upper left. (Courtesy of NASA.)

With Apollo 11's landing on the moon, Comdr. Neil Armstrong proclaimed, "The *Eagle* has landed." In this photograph taken on the lunar surface by Armstrong during the astronauts' extravehicular activity (EVA), Buzz Aldrin has just deployed the Passive Seismic Experiment Package, while behind it is the Laser Ranging Retro-Reflector, which was left on the moon and would allow precise measurements of the earth-moon distance. (Courtesy of NASA.)

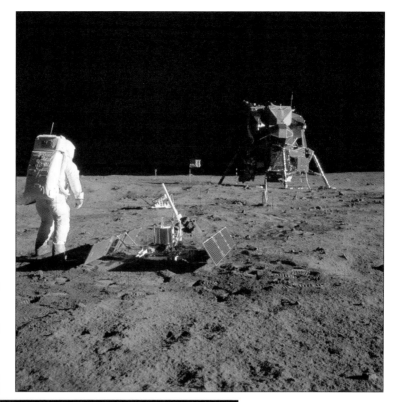

In November 1969, Apollo 12 astronauts Pete Conrad and Alan Bean made a pinpoint landing in the Ocean of Storms, only 600 feet from where the *Surveyor 3* spacecraft had been resting since April 1967. Its precise location was determined by selenography whiz Ewen Whitaker, for which he received a citation from Pres. Richard Nixon. The anthill-like feature shown here likely consists of ejecta from a crater. (Courtesy of NASA.)

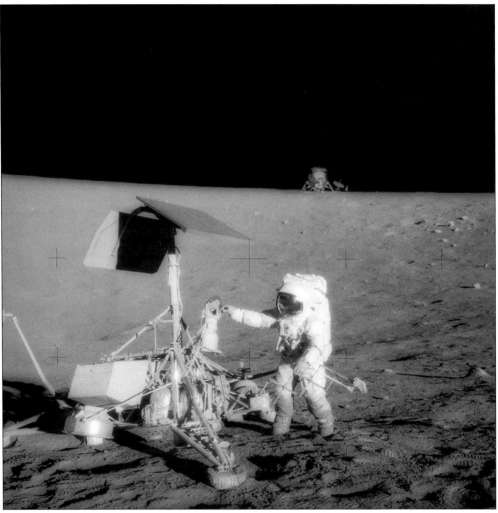

This unusual photograph, taken during the second Apollo 12 EVA, shows the lunar module in the background and the unmanned *Surveyor 3* spacecraft, which had soft-landed on the moon in April 1967, in the foreground. In this image taken by Alan Bean, Pete Conrad stands near the *Surveyor 3*. The astronauts dismantled the television camera and other pieces of *Surveyor 3* and returned them to Earth. (Courtesy of NASA.)

Copernicus, the "Monarch of the Moon," looms in the distance, a striking Apollo 12 orbiter view looking in a north-northwest direction obtained by Richard Gordon in the command module. The key-shaped depression near the southern edge of Copernicus is a double crater, Fauth (the larger portion on top) and Fauth A. Gordon used an 80-millimeter focal length lens to obtain this picture. (Courtesy of NASA.)

Here is Fra Mauro, the landing site for Apollo 14 in February 1971. This area, which is representative of the distinctive hummocky blanket surrounding Mare Imbrium, consists of ejecta from the impact of a 150-mile-wide asteroid, which formed the dominant multi-ring basin on the lunar near-side. Thus, it was of keen interest to geologists. This image was taken from *Apollo 16*. (Courtesy of NASA.)

A large boulder dominates the area near the rim of Cone Crater, the objective of Apollo 14 astronauts Alan Shepard and Edgar Mitchell, in February 1971. The astronauts failed to reach the rim, despite being within only 56 feet of it. However, they did recover material that appeared to belong to a ray from the crater Copernicus, giving it a date of 810 million years. (Courtesy of NASA.)

During their third EVA at their Hadley-Apennine landing site in July/August 1971, Apollo 15 astronauts Dave Scott and Jim Irwin look back at the lunar module standing, slightly tilted, on the lunar surface. The Apennine Front is in the left background; Hadley Delta Mountain is in the right background. The astronauts' footprints and tracks from their lunar rover are visible in front of the lunar module. (Courtesy of NASA.)

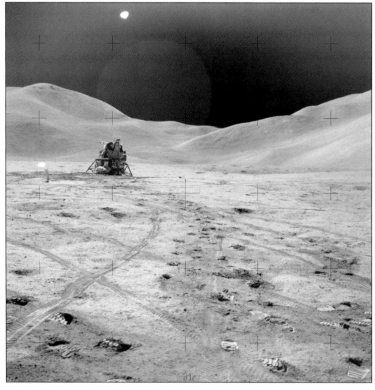

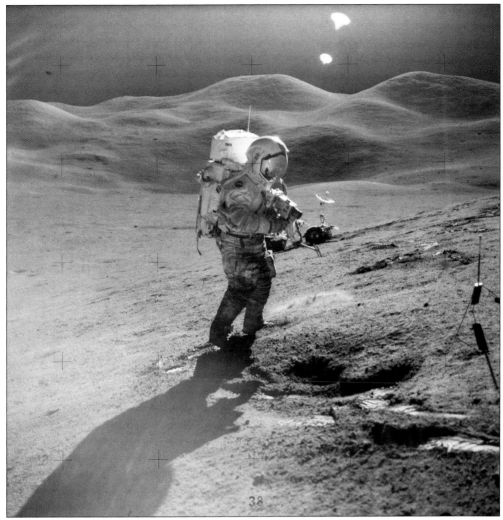

Dave Scott, Apollo 15 commander, stands on the slope of Hadley Delta. Though they appear just a stone's throw away, the Apennine Mountains in the background are actually 10.5 miles away—a testimony to the moon's complete lack of an atmosphere. The LRV, on which technicians based construction of the *Grover* prototype in Flagstaff, is in the background. (Courtesy of NASA.)

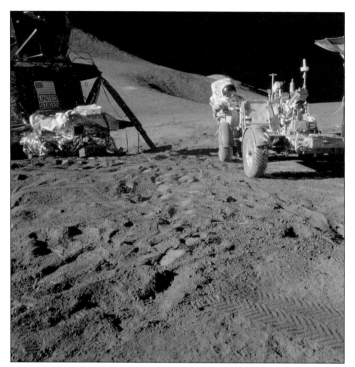

Astronaut Jim Irwin works at the LRV during the first Apollo 15 EVA at the Hadley-Apennine landing site. The LRV was key to the much wider explorations on the lunar surface accomplished by the Apollo 15 crew. This view looks toward Hadley Delta and the Apennine Front, in the background to the left; St. George Crater is about three miles in the distance, behind Irwin's head. (Courtesy of NASA.)

Here is the Imbrium "sculpture," first described by the great geologist Grove Karl Gilbert from observations made with the US Naval Observatory's 26-inch refracting telescope in 1892. The scarified landscape shown in this Apollo 16 image shows ridges and grooves formed by debris thrown out from the impact of a 150-mile-wide asteroid 3.8 billion years ago. (Courtesy of NASA.)

Apollo 16 landed in the Descartes region west of Mare Nectaris, which USGS geologist Dick Eggleton noticed looked like ejecta from Imbrium. However, because it was unusually bright, it was suggestive of possible secondary volcanic activity. Here, Comdr. John Young stands on the rim of Plum Crater while collecting samples during the first Apollo 16 EVA at the Descartes landing site. (Courtesy of NASA.)

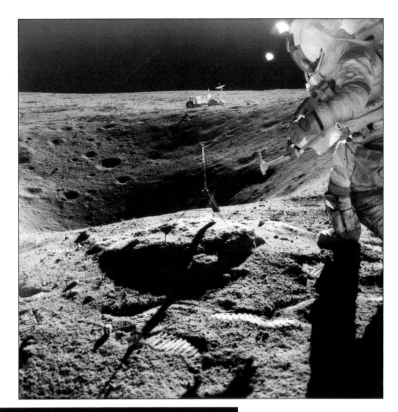

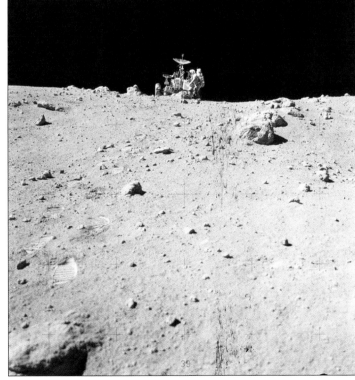

Astronaut Charlie Duke works in front of the LRV, which is parked in a rock field at the North Ray Crater geological site, during Apollo 16's third EVA on April 23, 1972. With a diameter of more than half a mile, this is the largest crater explored by any of the Apollo astronauts. (Courtesy of NASA.)

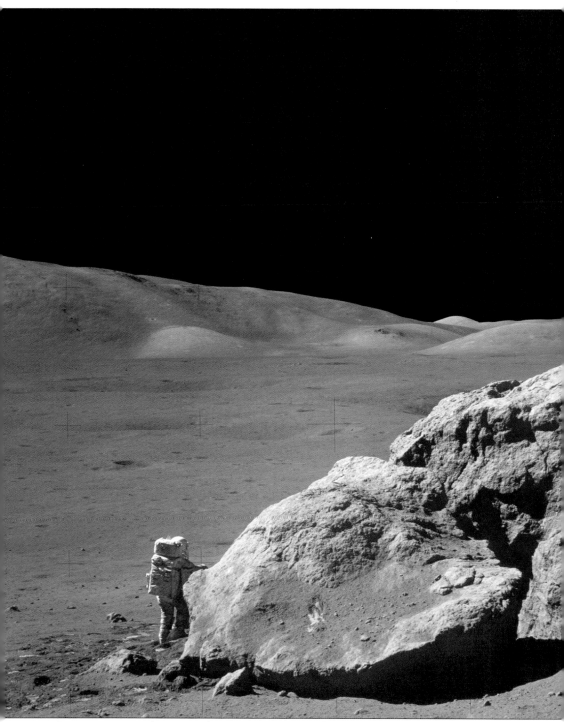

In a quintessential moment for scientists around the world, one of their own—geologist Jack Schmitt—explores the large boulder called "Split Rock" near the Apollo 17 landing site close to Taurus-Littrow. He and Gene Cernan explored this area on their third EVA and collected many samples, which scientists later used to determine that Split Rock was formed from rock melted

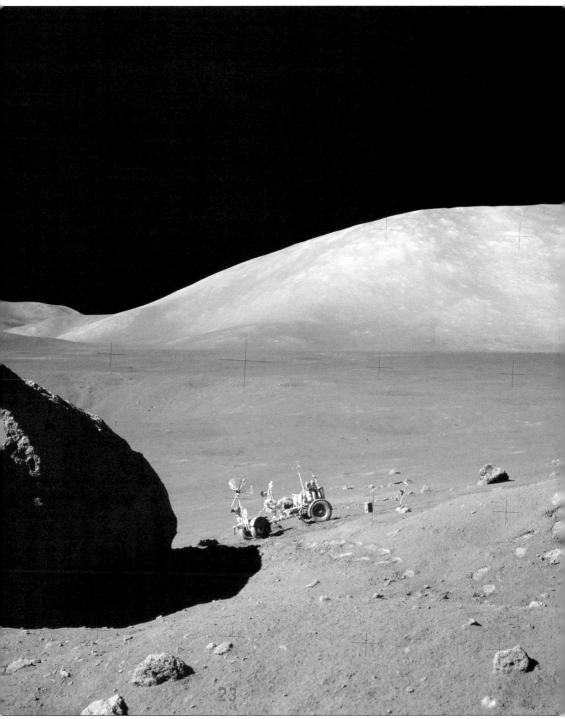

as a result of a meteorite impact. Studying Meteor Crater in northern Arizona, with its deposits of melted rock, well prepared Schmitt and Cernan for this work. This iconic photograph that Cernan took also shows the LRV, on the opposite side of Split Rock from where Schmitt stands. (Courtesy of NASA.)

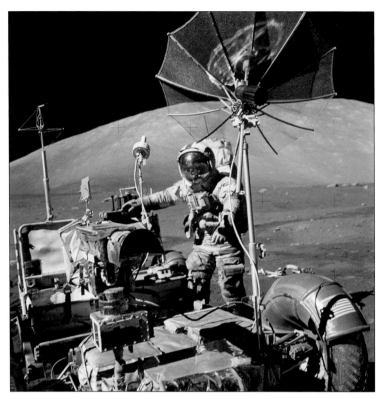

Gene Cernan stands with the LRV during the Apollo 17 mission. After the crew's final EVA, Schmitt climbed back into the landing module, leaving Cernan as the last person—to date—to walk on the moon. Thus, that December 1972 day ended humankind's first era of manned lunar exploration. (Courtesy of NASA.)

Forty-nine years after Neil Armstrong and his fellow astronauts climbed through the Grand Canyon to learn geology, he was back in northern Arizona to help Lowell Observatory dedicate its new Discovery Channel Telescope, shown here with Armstrong and Lowell astronomer Stephen Levine. Armstrong died a month later, but the legacy that he and his fellow astronauts created will forever live on. (Courtesy of Lowell Observatory.)

BIBLIOGRAPHY

Beattie, Donald. *Taking Science to the Moon.* Baltimore: Johns Hopkins University Press, 2001.

Chaikin, Andrew. *Man on the Moon.* New York: Viking, 1984.

Dutton, Clarence E. *Tertiary History of the Grand Cañon District.* Washington, DC: Government Printing Office, 1882.

Greeley, Ronald, and Raymond M. Batson. *Planetary Mapping.* Cambridge, UK: Cambridge University Press, 1990.

Hoyt, William G. *Coon Mountain Controversies: Meteor Crater and the Development of Impact Theory.* Tucson: University of Arizona Press, 1987.

Kring, David A. *Guidebook to the Geology of Barringer Meteorite Crater (a.k.a. Meteor Crater).* LPI Contribution No. 1355. Houston, TX: Lunar and Planetary Institute, 2007.

Lago, Don. "That's One Small Step . . . in the Grand Canyon." *The Ol' Pioneer: The Magazine of the Grand Canyon Historical Society.* Vol. 23, no. 2 (Spring 2012): 3–12.

Logsdon, John M. *The Decision to go to the Moon.* Cambridge, MA: MIT Press, 1970.

Phinney, William. *Science Training History of the Apollo Astronauts.* NASA SP-2015-626, 2016.

Schaber, Gerald G. *The U.S. Geological Survey, Branch of Astrogeology—A Chronology of Activities from Conception through the End of Project Apollo (1960–1973).* USGS Open-File Report 2005-1190, 2005.

Sevigny, Melissa L. *Under Desert Skies: How Tucson Mapped the Way to the Moon and Planets.* Tucson, AZ: Sentinel Peak, 2016.

Sheehan, William P., and Thomas A. Dobbins. *Epic Moon: a History of Lunar Exploration in the Age of the Telescope.* Richmond, VA: Willmann-Bell, 2001.

Shoemaker, Eugene M., and Susan W. Kieffer. *Guidebook to the Geology of Meteor Crater, Arizona.* Publication No. 17, Arizona State University Center for Meteorite Studies. Tempe: Arizona State University, 1974.

Whitaker, Ewen A. *The University of Arizona's Lunar and Planetary Laboratory: Its Founding and Early Years.* Tucson: University of Arizona, 1986.

Wilhelms, Don E. *To a Rocky Moon: A Geologist's History of Lunar Exploration.* Tucson: University of Arizona Press, 1993.

DISCOVER THOUSANDS OF LOCAL HISTORY BOOKS FEATURING MILLIONS OF VINTAGE IMAGES

Arcadia Publishing, the leading local history publisher in the United States, is committed to making history accessible and meaningful through publishing books that celebrate and preserve the heritage of America's people and places.

Find more books like this at
www.arcadiapublishing.com

Search for your hometown history, your old stomping grounds, and even your favorite sports team.

Consistent with our mission to preserve history on a local level, this book was printed in South Carolina on American-made paper and manufactured entirely in the United States. Products carrying the accredited Forest Stewardship Council (FSC) label are printed on 100 percent FSC-certified paper.

MADE IN THE USA